MASTER CLASS PHOTOGRAPHY SERIES

COLOR PROCESSING AND PRINTING

Ann Brandeis, formerly a member of the photography faculty at Rochester Institute of Technology, now teaches photography at the Fashion Institute of Technology in New York City. She holds a Master of Fine Arts degree from Pratt Institute. Her work has appeared in *POPULAR PHOTOGRAPHY* magazine, and she has had exhibits at a number of galleries, including Kodak Park. A specialist in aerial and fashion photography, Brandeis is also the former director of the Olden Photography Workshops.

The Master Class Photography Series
Better Black-and-White Darkroom Techniques
Creative Still Life Photography
Improving Your Color Photography
Techniques in Portrait Photography
In-Camera Special Effects
Color Processing and Printing

MASTER CLASS PHOTOGRAPHY SERIES

COLOR PROCESSING AND PRINTING

Ann Brandeis

A SPECTRUM BOOK

Prentice-Hall, Inc.
Englewood Cliffs, New Jersey 07632

For Guy and Kerry.

Project Editor: Sheila Rosenzweig
Art Director: Richard Boddy
Design Assistant: Mary Moriarty

Produced and prepared by
Quarto Marketing Ltd.
32 Kingly Court, London W1, England

Printed in Hong Kong by Lee Fung-Asco Printers Ltd.
Typeset by Associated Typographers
Separations by Hong Kong Graphic Arts Service Centre

This Spectrum Book is available to business and organizations at a special discount
when ordered in large quantities. For information, contact Prentice-Hall, Inc., General
Book Marketing, Special Sales Division, Englewood Cliffs, N.J. 07632.
A Spectrum book
10 9 8 7 6 5 4 3 2 1

ISBN 0-13-152207-8
ISBN 0-13-152199-3 {PBK.}

Library of Congress Cataloging in Publication Data
Brandeis, Ann
Color processing and printing.
(Master class photography series)
"A Spectrum Book."
Bibliography: p.
Includes index.
1. Color photography — Processing. 2. Color photography — Printing processes.
I. Title. II. Series.
TR530.B73 1983 778.6'6 83–11051

Contents

Introduction

AS A PROFESSIONAL PHOTOGRAPHER AND AS A COLLEGE teacher, I spend half my time taking pictures and the other half trying to teach what I do in the simplest, least confusing way. This book has been written to teach you the skills of color darkroom work in a logical, skills-building progression. You will learn the technical aspects of processing and printing, and also how to evaluate and improve your results. The goal is to make you independent in the darkroom as quickly as possible.

In addition to my own work, I have included images by well-known photographers who manipulate the technical aspects of color photography in a creative manner. Jim Collier and Joel Aaronson work extensively with posterization, Hal Berg uses prisms to alter reality, Irving Schild uses tricolor shooting and beautiful women in his work, Jessie Chou photographs light, and Guy Pierno and Sue Ann Miller are both journalists who have learned to shoot and move.

The words and pictures of this book form an integrated whole. The words explain procedures and techniques; the pictures show how to apply your darkroom skills creatively. By strengthening your technical abilities, you will be freer to think and experiment imaginatively, which is what photography is really all about: creative self-expression.

1

Controlling
Color Materials

TO ACHIEVE WORTHWHILE RESULTS IN THE color darkroom, you must first understand what color is and how color films work. The principles are really quite easy to grasp.

Light is made up of particles of electromagnetic energy called photons, travelling in waves of different length. Light wavelengths are very short and are measured in nanometers. Abbreviated nm, one nanometer equals one billionth of a meter, or .000000001 meter. The shorter the wavelengths, the more their energy. The human eye can perceive only those light waves that fall in the 380–760 nm range. Infrared light, at over 800 nms, is invisible to the eye (although not to special photographic films), while red light, at 600–700 nms, can be seen. Similarly, ultraviolet light, at about 350 nms, is outside the visible range, but blue light, at 400–500 nms, is within it.

When incident white light falls on an object, some of the photons are absorbed, some are transmitted, and some are reflected. The eye sees an object only by the light it reflects. The wavelengths an object reflects, based on its structure, determine its color. Black velvet absorbs almost all the light that falls on it; white snow reflects almost all the incident light. A tomato, however, appears red because it absorbs lights in the violet to green wavelength range and reflects orange-red wavelengths.

DEFINING COLOR

Any color is defined by a combination of three factors: its hue, chroma, and value. Hue is the name of the color, determined by its wavelength. Chroma refers to the purity, strength, or vividness of the hue. Often called saturation, a

color's chroma is reduced by the addition of white, as when bright red paint is reduced to light pink by adding white. In photographic terms, a color's chroma is often weakened by the addition of light – that is, overexposure. The final color term is value, which refers to the relative darkness or lightness of the color, and is affected by the intensity of the ambient light. How the eye perceives the hue, chroma, and value of a color is affected by the surrounding environment.

ADDITIVE COLOR

When white light is passed through a prism, it is broken up into a rainbow of spectral colors – red, orange, yellow, green, blue, and violet. If the spectrum produced by the prism were then passed through another prism, the result would be white light again. The six spectral colors so produced can be seen only with a prism or through a rainbow (a form of natural prism). In practice, it is the three additive primary colors, red, blue, and green, that combine to form white light. They are called additive primaries because they add color where none existed; in other words, they introduce color to an area otherwise black. Since red, blue, and green are pure spectral colors, when light beams of two are mixed together in

ADDITIVE COLOR COMBINATIONS
The primary additive colors are
red, blue, and green.

Combination	Product
red + blue	magenta
red + green	yellow
green + blue	cyan

Using a prism, Sir Isaac New-
ton proved that white light is a
mixture of all the colors of the
spectrum. When sunlight is
passed through a prism, the dif-
ferent wavelengths of which it
is made are refracted in varying
degrees — the shorter the wave-
length, the more it is bent — and
split into the familiar rainbow
colors of the visible spectrum.
Photo by Hal Berg.

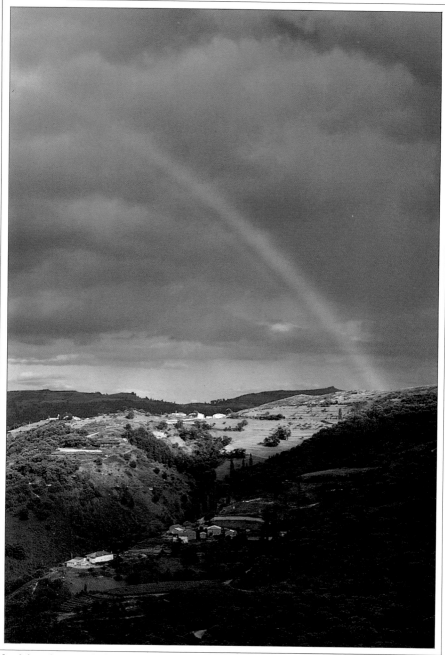

A rainbow is created when the sun's rays are refracted or bent as they enter a raindrop, reflected within the raindrop, and refracted again as they emerge. Each raindrop acts as a tiny prism, creating in summation the visible spectrum. Since each wavelength is refracted at a specific angle (red wavelengths at 42°), each wavelength emerges at a different angle, creating the arc or bowing effect.

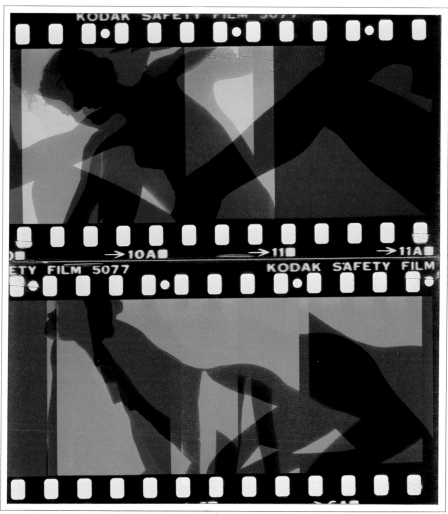

This photograph was taken on Ektachrome film, using colored filters and multiple exposures to create the additive effect. Three successive exposures were made on the same piece of film, using first a red filter, then a blue filter, and then a green filter. The model moved in between exposures. Where any two primary colors overlap, a secondary color is formed. Red and green mix to form yellow, red and blue mix to form magenta, and blue and green mix to form cyan. Where no primary colors overlap, the original color stays pure. Photo by Irving Schild.

equal proportions, they form light of a secondary color. For example, if a beam of green light were projected onto a white screen, and a second, equally intense beam of red were projected next to it, yellow would appear where the red and green beams overlapped. If a blue

beam were added, white would appear where all three beams overlapped.

The secondary color magenta is produced when equal parts of red and blue light combine; blue and green light combine to form the color cyan. When primary colors are mixed in unequal

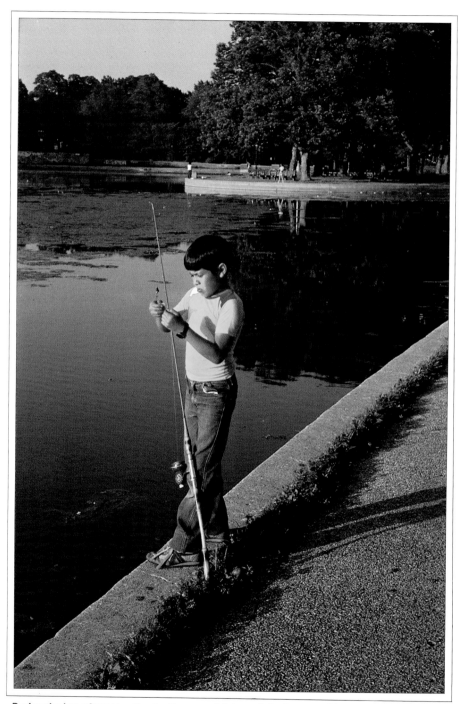

During the late afternoon, the slanting rays of light and shadow reveal form and texture. As this shot shows, this kind of light can have an almost magical quality. Photo by Guy Pierno.

If the color and mood of the image are manipulated, it can create an even stronger point. In this photograph by Sue Ann Miller, taken on the day of the Three Mile Island nuclear generator accident, the overall blue-gray quality (due to the rainy, overcast weather) reflects the very somber atmosphere of that day.

proportions, intermediate colors are formed. For example, one part red and two parts blue produce purple; two parts red and one part green produce orange.

The easiest way to project red, blue, and green beams of light is by passing the light through filters. An additive color filter functions by allowing only light of its color to pass through it. Thus, only one-third of the white light striking a filter is transmitted. In the case of a red filter, for example, red light is transmitted while blue and green light are blocked. This means that additive colors can combine to create other colors only when separately projected. If two primary color filters are stacked in white light they produce black or the absence of color, since all the light striking the filters is blocked.

Early color reproduction experiments by such photographic pioneers as Niépce

and Daguerre tried to use additive color. But because even today spectral colors stable enough to withstand the light required to view them by don't exist, one of the modern applications of additive color is the television screen.

SUBTRACTIVE COLOR

If the band of spectral colors produced by a prism is bent around into a circle, joining the red and violet ends, the familiar color wheel is formed. Opposite the three primary colors on the color wheel are their complements, the secondary colors cyan, magenta, and yellow. As we've seen, adding two primary colors together produces a secondary color. Consequently, if two secondary color filters are overlapped, they produce not blackness but a primary color; only if all three secondary colors are combined does blackness result.

The color temperature of daylight changes continuously as the day progresses. The first rays of the sun have an orange glow, giving a warm cast to the photograph. Early light filtering through mist or fog will reflect a colder, bluish light. In this shot the colors of the airplanes are muted, the light is delicate, and the mood is soft.

SUBTRACTIVE COLOR COMBINATIONS

The primary subtractive colors are magenta, cyan, and yellow.

Combination	Product
magenta + yellow	red
magenta + cyan	blue
cyan + yellow	green

For example, cyan is created by the mixture of blue and green. A cyan filter blocks, or subtracts, all colors but blue and green from a beam of white light. Blue and green light are transmitted; red is subtracted.

The secondary color yellow is created by the mixture of green and red. If a cyan and yellow filter are combined, then, they subtract both the red and blue wavelengths from the white light and transmit the primary color they have in common, green. Finally, if a magenta filter is added to the pack, it blocks the

At noon, the Kelvin temperature is about 5,400°. Daylight films are balanced for this time of day, even though it is the least desireable time for picture-taking. At noon on a very bright day, the light is harsh, the shadows fall beneath the subject, and the light is often too contrasty for the film. In this photo, there are few midtones, overly bright highlights, and dark, blocked-up shadows.

green light, since magenta is created by the mixture of red and blue. The result is black.

SUBTRACTIVE COLOR TRANSMISSION

Filter	Subtracts	Transmits
magenta	green	red + blue
cyan	red	blue + green
yellow	blue	red + green

The differences between additive and subtractive color are a little confusing at first, but they are really only opposite sides of the same coin. The additive primaries produce color where there is darkness, as inside your camera or darkroom. The subtractive primaries produce colors where there is light, such as daylight. The charts on pages 9 and 16 help make the relationships clear.

As we'll see in the later chapters, the principles of additive and subtractive color are important to understanding how the different types of color films and papers work, and for understanding the principles of color correction and color filtration.

COLOR TEMPERATURE AND COLOR BALANCE

No amount of darkroom manipulation can compensate for a shot taken on the wrong film or for a poorly exposed shot. For example, there is no satisfactory way to correct in the darkroom the orange-red cast of daylight film exposed under tungsten lights. The integrity of the image is affected by the quality of the light and the exposure. Several film variables also will affect the image, including the film's latitude, contrast,

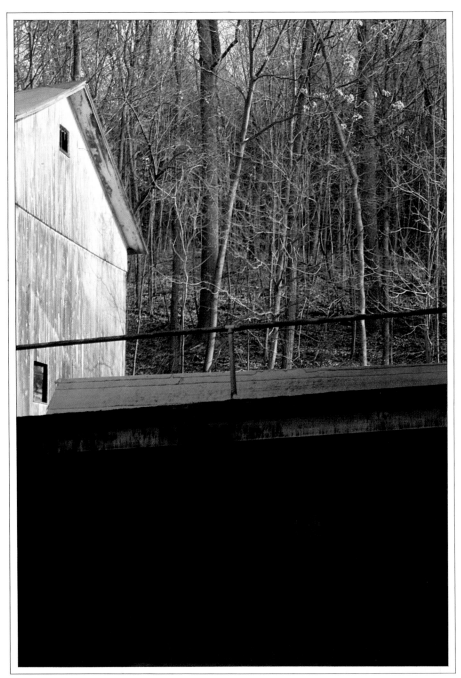

Tungsten film is balanced to give a correct color reading at 3,200° Kelvin. Since daylight has more blue and less red, tungsten film used outdoors shows a pronounced blue bias, as in this photograph. Although the picture was shot in the afternoon during the warm part of the day, the overall feel is quite cold. This cannot be corrected in the darkroom.

When daylight film is exposed under tungsten lighting, the colors become warm and the image has an overall orange cast. Reds and oranges become dominant, and blues and greens are subdued. Again, this cannot be corrected in the darkroom.

grain structure, color bias, and development. If you get the shot right to begin with, life in the darkroom will be a lot easier. The information below should be of help.

Observant photographers know that the quality of sunlight is different at high noon than it is at dawn. Noon light has virtually no color bias; dawn light is reddish. Indoors, tungsten and fluorescent lights have their particular color qualities as well. Although the human eye can't perceive a difference between shades of white light, film is a great deal more sensitive. The photographer's problem, then, is to find a way of recording color accurately. To do this, a basic understanding of the concept of color temperature is needed.

When a substance, say the filament of a lightbulb, is heated, its color changes as it gets hotter, glowing first red, then orange, yellow, white, and finally blue. Color temperature is a scale used to

measure the color, not the actual heat, of the light emitted. The scale is calibrated in degrees Kelvin; the sun at high noon, at 5,500° K, is the standard for white light. At sunset or dawn, when the sunlight contains more red wavelengths, it has a color temperature of about 2,000° K. At high noon on a reflective beach or at high altitudes, the color temperature may be as high as 10,000° K or even more, giving a distinct bluish cast to the shadows. Indoor lighting with standard tungsten lightbulbs has a color temperature of around 3,200° K.

Because the wide variations of color temperature from various light sources is too much for any one film emulsion to handle, color films are divided into daylight (Type A) and tungsten (Type B) films. Daylight films are balanced to 5,500° K and are designed to give accurate color when used with sunlight or with flash. Tungsten films are balanced to 3,400° K. They are designed to give

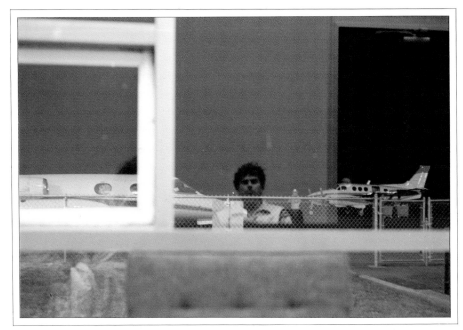

Color photographs taken by unusual light sources will never have a correctly balanced appearance. Some light sources, such as fluorescent or mercury-vapor lamps, do not produce a full range of light wavelengths. Fluorescent lighting, if uncorrected, will produce an overall green cast. In the photograph above, the green fluorescent tinge is easily seen in the white window frame and in the reflection of the face. A magenta filter on the lens can reduce the green cast when shooting transparencies; little can be done about it in the darkroom. Firelight and floodlight, shown in the photographs at right, are difficult lighting situations. The color temperature of a flame is about 1,900° Kelvin, which is the red portion of the spectrum. Both daylight and tungsten films will record a flame with a shift to the red-orange end of the spectrum.

correct results when used indoors with household or studio lighting. If you must use daylight film with tungsten lights, use a bluish filter such as an 80B to compensate for the built-in orange-red cast of the daylight film. Conversely, tungsten film used outdoors will give the scene a distinct bluish cast. Use an amber-colored filter such as an 85A to compensate. Fluorescent light is a tricky case, and there are no rules. In general, fluorescent lights have a greenish cast, so try using a magenta filter with daylight film. Use the chart on page 24 to determine the color temperature of common light sources.

FILM SPEED

The sensitivity of a photographic emul-

sion is indicated by its ASA, DIN, or ISO rating. The ASA rating system is common in the United States, while the DIN system is frequently used elsewhere. The ISO rating system, established by the International Standards Organization, has recently been adopted by many manufacturers, including Kodak. This rating combines the ASA and DIN ratings.

Whatever the system, the higher the rating, the faster the film. Slow films generally have a finer grain structure and provide more saturated color. Middle-range films still provide good saturation, but their grain is noticeable. The fastest, most sensitive films allow shooting in poor light, but their grain structure is easily apparent.

Nothing affects the feeling of a color photograph as much as light and its changes in quality, direction, height, and color. Harsh contrasty lighting is produced by a direct, undiffused light source, in this case the sun on a bright day. In this shot, the high-contrast light is well controlled. The colors are very saturated, creating a dramatic statement. Photo by Guy Pierno.

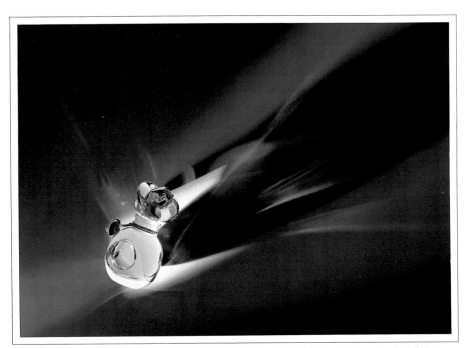

The photo above shows specular highlights that have been well controlled in a studio lighting situation. Specular light, or glaring hot spots caused by small areas of directional light, often destroy an image. Here specular light is used to create a sense of drama and a feeling of movement. Photo by Jessie Chou.

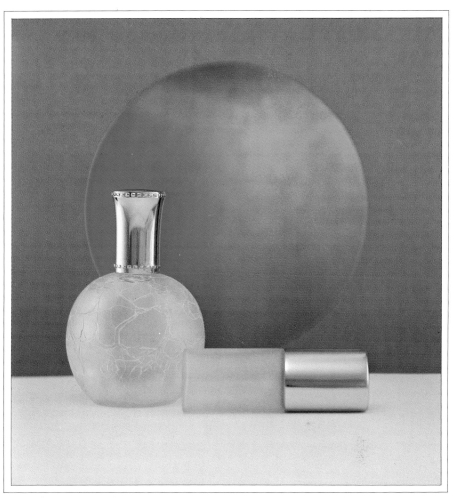

The perfume bottles in this shot demonstrate soft, muted lighting using a diffused light source. This creates an image with lower contrast and delicate tones. Photo by Jessie Chou.

Backlighting, when controlled, can be a dramatic visual tool, outlining the subject with light. Most through-the-lens meters will be fooled by backlight, often causing an incorrect reading and underexposure in the main subject. Compensate for backlighting by opening up 1½ stops, or by using a flash unit or fill card. A white fill card was used to lighten the boy's face.

EXPOSURE LATITUDE

Color films have a narrow exposure latitude, much narrower than black-and-white films. Most color negative films have an exposure latitude of 1½ to 2 full f-stops; they tolerate overexposure better than underexposure. Color transparencies give even less margin for error. The faster transparency films allow a latitude of about one stop in either direction. Slower transparency films, such as Kodachrome 25 and Kodachrome 64, allow only half a stop either way.

The effective brightness range for color negative films is 8:1, or a difference of 3 f-stops between the brightest and darkest portions of the picture. Color transparency films can handle a brightness range of only 3:1, or a difference of 1⅔ f-stops between the highlight and shadow areas. Another way to think of the brightness range is in terms of contrast. Bright directional light creates a very contrasty situation, one that is often overly bright, with few midtones and washed-out color saturation and details. Such situations, with brightness ratios of 32:1 (5 f-stops) or even 64:1, are far beyond the capacity of the film to record. To photograph a contrasty scene, meter your shots accurately, and reduce the brightness range either through supplemental lighting or careful filtration.

Some films seem to give better results when slightly under- or overexposed. Kodachrome 25 and Kodachrome 64, for example, give more vibrant color when underexposed by one-third of a stop. The maximum underexposure for these films should be no more than one stop; the maximum overexposure no more than one-half stop.

GRAIN STRUCTURE AND SHARPNESS

Sharpness and grain structure are closely related. A film with a fine grain structure produces an image that is crisp, clear, and well-defined. Slower films have finer grain. Faster films are grainier because the silver crystals in them are

COLOR TEMPERATURES OF COMMON LIGHT SOURCES

Daylight sources	Temperature in Degrees Kelvin
Sunlight — mean noon	5,400
Blue sky — north light	15,000-27,000
Open shade	10,000-18,000
Hazy skylight	7,000-9,000
Overcast sky	6,500-7,000
Hazy sunlight	5,700-6,000
Morning or afternoon sunlight	5,000-5,500
Direct sun at dawn or sunset	3,000-4,500
Sunlight one hour after dawn	3,500
Early morning or late afternoon sunlight	4,300

Artificial sources	
Match flame	1,700
Candle flame	1,850
100-125-watt tungsten bulbs	2,600-2,900
3,200-degree photo lamps	3,200
Photofloods	3,400
Blue-coated photofloods	4,800

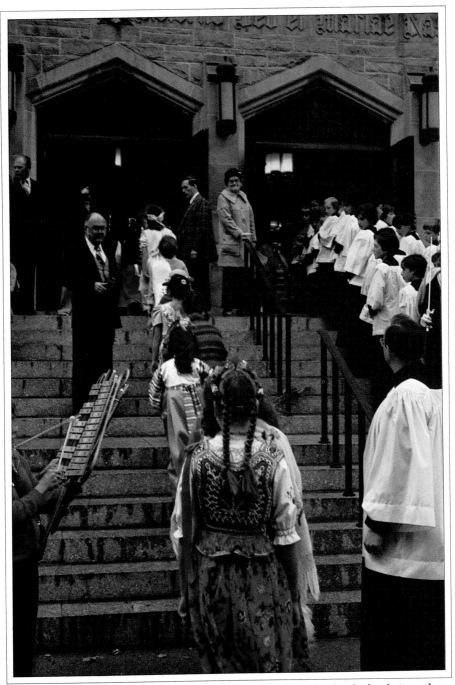

The high contrast of midday light can be an asset, given the right situation. In the photograph here, the high-contrast light causes the colors to become more saturated, eliminates unnecessary details, and given the white shirts of the choir a luminescent quality.

NORMAL EXPOSURE: f/8

Color films have a very narrow exposure latitude — one-and-a-half f-stops for negatives, one-half f-stop for transparencies — leaving no margin for error. These three photographs show half-stop exposure variations. At each f-stop, a different portion of the image is best represented. At the "correct" exposure, the white flower has detail; at a half-stop over, the yellow is brightest; at a half-stop under, the red and brown tones are most vibrant.

larger but more sensitive to light. Graininess is also the result of uneven distribution or clumping of the silver particles. This is an inherent characteristic of some films. Exposure and development also affect grain structure. Overexposure or overdevelopment (either from extended development or high developer temperature) will increase the grain structure of the film dramatically.

COLOR BIAS

Most color films have a built-in bias toward one or two colors. A color bias gives a particular film its personality, and allows it to render certain colors more dramatically. The differences among films are subtle, and which you choose to use is purely a question of personal taste. Be aware, though, that the color bias of some films may give flesh tones an undesirable color cast. You should be able to solve the problem with filtration.

RECIPROCITY FAILURE

Theoretically, film exposure equals the light intensity multiplied by the exposure time. In other words, an exposure of $\frac{1}{125}$ second at $f/4$ is the equivalent of an exposure of $\frac{1}{60}$ second at $f/5.6$. However, if the exposure is longer than about one-quarter of a second, this equation no longer holds true with most color films. Unless an exposure compensation is made, the shot may have a color cast, often tending toward blue or purple, because the different emulsion layers of the film react differently to long exposure. Since tungsten-balanced films are designed for slower speeds, reciprocity failure is less of a problem with them.

Suggestions for reciprocity failure correction are included with the instructions for each roll of film. Generally, correction involves a combination of increased exposure and filtration, and varies from film to film. A chart in the technical in-

OVEREXPOSURE: f/5.6½

UNDEREXPOSURE: f/8½

formation section of this book lists exposure compensations and filters for correcting reciprocity failure in popular color films.

THE NEW HIGH-SPEED FILMS

Kodak has recently introduced a new color negative film called Kodacolor VR

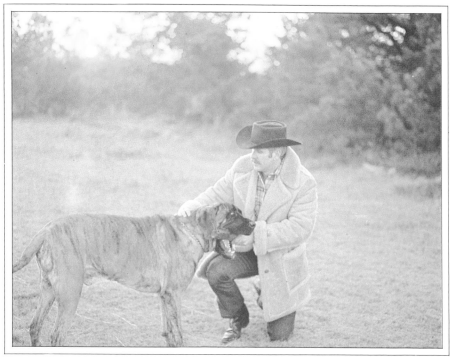

Overexposing transparencies will produce a pale image lacking fine details and dominant tones. However, this effect can also be termed "atmospheric" and used creatively, as in the shot above, which is four stops overexposed. Specific tones can be further heightened in the darkroom. Underexposing negatives will also produce a pale image lacking fine details. The photo at right was made from a negative underexposed by three stops. It is very difficult to get creative results with an underexposed negative; strong silhouettes are usually all that can be done.

1000. The fastest color film now available, this film represents a breakthrough in silver halide emulsion technology. It uses a flattened, tablet-shaped grain called a T-grain, which yields a more light-sensitive film without increasing graininess or sacrificing sharpness. In addition to the new grain structure, this film also uses an improved dye-coupler image technology. The new emulsion layering requires no yellow filter layer, and spectral sensitizing characteristics in the emulsion minimize the differences between light sources, allowing good color reproduction under daylight, flash, or artificial light. Most importantly, Kodacolor VR 1000 is processed using the easily accessible C–41 process.

Fuji has also introduced a new concept in color film technology. Called HDCP (for high-density coupler particles), films using this technology provide superior sharpness and finer grain. The new coupler particles create a higher dye density and a thinner emulsion, which leads to improved image sharpness. The finer grain is made possible by new, multifaceted silver halide particles.

The most revolutionary of the new films is an instant transparency film from Polaroid called Polachrome Autoprocess. This 35mm system requires a special processing unit for developing the film. The chemistry is provided in

processing packs sufficient for one roll of film. Processing time, including loading, takes about five minutes. Polachrome is rated at ASA 40, and comes in rolls of 12 or 36 exposures.

COLOR NEGATIVE FILMS

Color negative films are quite stable, with little color bias and more exposure latitude than slide films. Below is a discussion of the most common color negative films. The chart on page 31 lists film brands, the sizes available, and the recommended lighting.

Kodacolor. Kodacolor II and Kodacolor 400 are the most widely used color negative films. Both films have a wide

brightness range, and both tolerate overexposure (up to 2½ stops) and underexposure (up to 1½ stops) well. Kodacolor II has a finer grain; Kodacolor 400 has higher contrast.

Vericolor Type S. Vericolor II and Vericolor II Type S are daylight-balanced films designed for use by professional portrait, commercial, and industrial photographers. Type S films are extremely stable, with a fine grain structure. They are available in sizes for all format cameras. These films are balanced for optimum skin-tone reproduction and short exposures of from ½₀₀₀ to ⅒ second. Exposures longer than ⅒ second may require additional filtration. Vericolor II

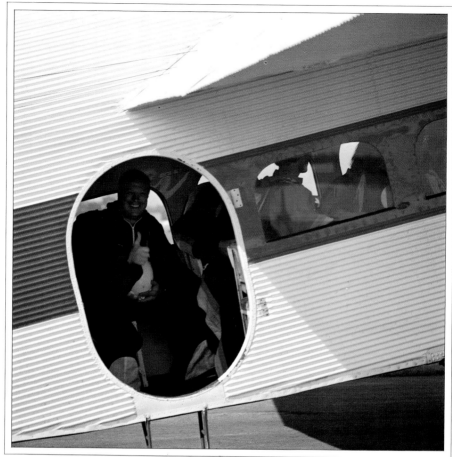

With a brightness range of only 3:1, transparency films must have relatively even lighting or details will be lost. Inside-outside situations are tricky; often one area must be sacrificed to gain another. In the picture above, the decision was made to expose for the highlights to capture the white-on-white pattern on the fuselage of the aircraft. The shadow portion was allowed to get a bit dark; it was lightened in the darkroom later. Photo by Guy Pierno. The picture on the right is a more successful approach to a contrasty lighting situation. The picture was taken later in the day, when contrast was reduced and clouds had come in. The exposure was for the shadow.

commercial film is higher in contrast than Vericolor professional film.

Vericolor Type L. Designed for professionals, Vericolor Type L is tungsten-balanced and is higher in contrast than Type S film. Color errors will result if it is exposed at less than $\frac{1}{50}$ second.

COLOR TRANSPARENCY FILMS

Nearly 30 good color transparency films are now available. Not all are available everywhere, however, so the discussion here will concentrate on the characteristics of the most commonly used films. The chart on page 32 lists film brands, the sizes available, and the recommended lighting.

Kodachrome 25 has exceptionally fine grain structure, produces a crisp, sharp image, and makes high-quality enlargements. Its color reproduction is generally accurate, although it has a slightly warm cast. Skin tones appear very natural; reds and greens are highly saturated; brown

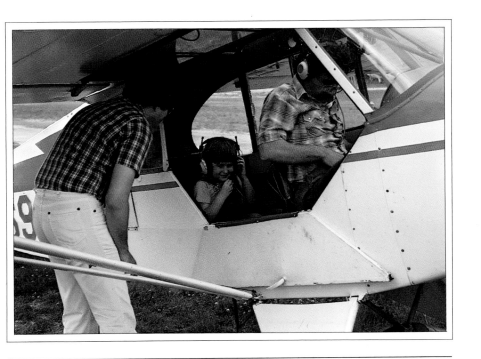

COLOR NEGATIVE FILMS

Film	Recommended Lighting	Sizes Available
Kodacolor II (ASA 100)	Daylight	110, 35mm, 126, 127, 620, 120, 116, 616, 828, disc
Kodacolor 400 (ASA 400)	Daylight	110, 35mm, 120
Kodacolor VR 1000 (ASA 1000)	Daylight	35mm
Vericolor II Type L (ASA 100)	Daylight and tungsten long exposures	35mm, 120, 4 × 5, 8 × 10
Vericolor II Type S (ASA 100)	Daylight short exposures	35mm, 120, 220, 70mm, 4 × 5, 8 × 10
Vericolor III (ASA 100)	Daylight	35mm
Agfacolor CNS-2 (ASA 80)	Daylight	35mm
Fujicolor FII (ASA 100)	Daylight	110, 35mm, 120, 126
Fujicolor FII 400 (ASA 400)	Daylight	110, 35mm, 120
3M Color Print Film	Daylight	110, 35mm, 126
3M High Speed Film	Daylight	110, 35mm

tones are a bit dark. For best results, expose at its rated speed. Kodachrome 25 has excellent contrast, but it also has a narrow exposure latitude of one stop underexposure and only one-half stop overexposure.

Kodachrome 64 shows a barely noticeable grain structure with no clumping. It has a very slight red cast, with warm skin tones and a red bias noticeable in the highlights. Reds and greens are highly saturated; browns appear correctly. The best exposure for this film is one-half stop below its rating. An overexposure of more than two-thirds of a stop will yield washed-out colors.

COLOR TRANSPARENCY FILMS

Film	Recommended Lighting	Sizes Available
Kodachrome 25	Daylight	35 mm
Kodachrome 40	Tungsten type A	35mm
Kodachrome 64	Daylight	110, 35mm, 126
Ektachrome 50	Professional tungsten	35mm, 120
Ektachrome 64	Professional daylight	35mm, 120, 70mm, 4 × 5, 8 × 10
Ektachrome 64	Daylight	110, 35mm, 126, 127
Ektachrome 160	Tungsten	35mm
Ektachrome 160	Professional tungsten	35mm, 120
Ektachrome 200	Daylight	35mm, 126
Ektachrome 200	Professional daylight	35mm, 120, 70mm
Ektachrome 400	Daylight	35mm, 120
Ektachrome 6118	Professional tungsten	4 × 5, 8 × 10
Agfachrome 64	Daylight	35mm
Agfachrome 100	Daylight	35mm
Agfachrome 200	Daylight	35mm
Agfachrome CT18	Daylight	120
Fujichrome 50	Daylight	35mm
Fujichrome 64 Professional	Professional tungsten	4 × 5, 8 × 10
Fujichrome 100	Daylight	35mm
Fujichrome 400	Daylight	35mm
Fujichrome 50D and 100D	Professional tungsten	35mm, 2¼
3M Color Slide Film 64	Daylight	126
3M Color Slide Film 100	Daylight	35mm
3M Color Slide Film 400	Daylight	35mm
3M Color Slide Film 640T	Tungsten	35mm
Polachrome 40 Instant Slide Film	Daylight	35mm

Ektachrome 64 is a very sharp film with noticeable grain. It has a slight yellow cast, giving noticeable yellow in the highlights and making the green tones appear slightly yellow. The yellows are very vibrant, but blue sky looks more cyan. The best exposure for this film is one-half stop below its rating. It will tolerate one full stop of either under- or overexposure.

Ektachrome 64 Professional also has a slightly yellow cast, with rich greens and warm reds and browns. It is slightly more contrasty than regular Ektachrome 64, and also slightly sharper. It is more tolerant of overexposure, with a latitude of up to 1½ stops overexposure. The best exposure is at the rated speed or one-third stop under.

Ektachrome 200 is high in contrast, and highlight areas can easily burn out.

Its grain structure is noticeable, but sharp. Ektachrome 200 has a yellow cast that produces yellow skin tones and strong greens. The best exposure is at the rated speed; its latitude is only one-half stop in either direction. Some photographers overexpose it to produce faint, ethereal colors.

Ektachrome 200 Professional produces skin tones that appear more natural than Ektachrome 200. Its grain structure is noticeable, but is extremely sharp-edged with no clumping. This film has a narrow exposure latitude of only one-half stop in either direction.

Agfachrome 64 has a somewhat grainier structure and higher contrast than other ASA 64 films, but still appears sharp. It has a red bias, yielding vibrant red tones and rich, warm browns and yellows. However, the greens have red in

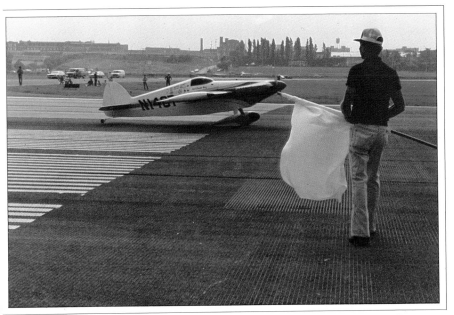

Flare can work for and against a photographer. Overall flare from an uncoated lens, or from catching the sun directly in the lens, can be intrusive. It lessens color saturation, as in this photo. However, flare can also be used as a dramatic creative tool, as in the picture on page 28. Flare will also cause incorrect exposures, since the meter will be fooled into reading too much light and then indicating an overexposure.

them; dark greens turn a muddy brown. The exposure latitude for Agfachrome 64 allows one stop underexposure and only one-half stop overexposure. Because of the film's high contrast, overexposure bleaches out the highlights, especially in skin tones.

Agfachrome 100 produces a picture with noticeable grain structure and a slightly soft edge structure. It is high in contrast, but has less of a red bias than Agfachrome 64. Its reds are very bright and its yellows well saturated. It tolerates underexposure better than other ASA 100 films because of its high contrast, but it will tolerate only one-half stop overexposure.

Fujichrome 100 has an obvious grain structure, and though its sharpness is good, the soft-edged grain limits fine detail and makes the image seem less sharp. It has a moderate magenta color bias, visible in highlights. Reds are well saturated, but greens are very yellow.

The blues have a lot of magenta, and sky records as a purplish hue with pink clouds.

Fujichrome 400 is a bit soft-edged, with obvious grain structure. A slight red cast is seen in the highlights. This film has good shadow detail, but only fair highlight detail, with moderate contrast. The best exposure is at the rated speed. Fujichrome 400 is tolerant of only one-half stop underexposure, but of a full stop overexposure.

3M 640T has the distinction of being the world's fastest tungsten-balanced transparency film. Compatible with Kodak's E-6 chemistry, it can be exposed at its rated speed or easily pushed to Exposure Index 1280 without much loss. Its grain structure is similar to that of Ektachrome 400, but it is extremely sharp. The grain is more noticeable in highlight areas. This is a very warm film, but it reproduces colors accurately, without a distinct color bias.

2

Processing
Film and Paper

HOME PROCESSING OF COLOR FILM IS SURPRIS-ingly simple, with one exception. Koda-chrome slide film, and its equivalent from other manufacturers, requires some 60 tightly controlled steps to process, and must be done by a professional lab with the necessary elaborate equipment. Almost every other popular color film, whether print or slide, can be success-fully processed in the home darkroom. But before moving on to a step-by-step explanation of how to process and print color films, you should understand how they work.

HOW COLOR NEGATIVE FILMS WORK

Color negative films such as Kodacolor, Ektacolor, and Agfacolor basically con-sist of three emulsion layers (instead of one in black-and-white film) coated onto a clear acetate base. Each emulsion layer consists of both silver halide particles and a chemical called a color coupler, which will react later with chemicals in the developer to form dyes. Each emul-sion layer is sensitive to a different ad-ditive primary color. Thus, the bottom layer of the film is sensitive to red light; the middle layer to green light; and the top layer to blue light. (In between the light-sensitive layers are clear gelatin lay-ers to separate them; there are also anti-halation and antiscratch layers, but none of these are important to the processing.)

When the film is exposed in the cam-era, the silver halides in each layer react proportionately to the primary additive colors in the scene. A red object would be primarily recorded in the red-sensitive layer, but to the extent that any color is a mixture of the primary colors red, green, and blue, it is recorded proportionately in the corresponding layers. A yellow object in the scene, for example, would be recorded in both the red and green layers. Where the subject is black no emulsion is exposed; where the subject is white all three layers are exposed equally.

Developing the film converts the ex-posed silver halides into a black, metallic silver negative image in each emulsion layer. The principle is the same as in black-and-white film. The difference is that during development, as part of a complicated chemical process, the color couplers in the emulsion layers react with chemicals in the developer to form dyes. The color couplers in the red-sensi-tive emulsion form cyan dye; those in the green-sensitive layer form magenta dye; and those in the blue-sensitive layer form yellow dye. The colors of the proc-essed negative film are a negative image of the subject. During printing the col-ors are reversed and the original colors are reproduced on the print. During processing the color couplers also form the familiar orange mask seen on the col-or negative. The mask is a built-in form of color correction, and improves the accuracy of the colors in the final print.

The black silver image in each layer is produced in proportion to the amount of dye in each layer, and must be re-moved before the negative can be printed. The film is therefore put into a bleach bath to change the silver into a soluble form that is then washed away during fixing. Many development processes now combine these two procedures into a step called blix (bleach-fix). A water rinse and stabilizer are the final steps in processing.

MAINTAINING PROPER TEMPERATURES

Color developing systems generally require the various solutions to be held at a constant temperature. The importance of maintaining each chemical, especially the developer, at its recommended temperature cannot be overstressed. Temperature is the weak link in the color processing system. Fluctuations in temperature will be seen as development variations and color shifts in the final product. If you are unaware that a temperature change has taken place, you may find yourself with an unexpectedly under- or overdeveloped result.

The simplest and least costly way to maintain the correct temperature of the various chemical solutions is to use a water bath. Although water baths are best done in or near a sink with running water, a sink is not absolutely necessary. Use a tray large enough to hold all the chemical containers, and deep enough so that the water will reach nearly to the top of the containers. Do not overfill the tray or the containers may float, and the chemistry then may become diluted by water.

Set all containers in the tray and fill it with water. The temperature of the water should be from one-half to $1\frac{1}{2}$ degrees higher than the desired temperature. Stir the solutions with a thermometer, and check the temperature often. Maintain the temperature of the water bath by adding small amounts of hot water, or by using a small immersion-coil heater. If a water rinse is needed, a container with water can also be set into the water bath in preparation for that step. During film development, the developing tank can also be set in the water bath when it isn't being agitated.

The water bath system also works well when you wish to warm up or cool down chemistry to a specific temperature. The water bath can be made 10–15° hotter or cooler than the desired temperature to speed up the warming or cooling time.

PROCESSING COLOR NEGATIVE FILM

The first step in *any* darkroom work is reading and understanding the directions. The next step is preparing the chemistry. Successful results in the color darkroom depend a great deal on careful and systematic work habits. The area and all tools and containers should be clean, all chemicals and solutions carefully labeled, and all equipment set up before you begin processing. Wear plastic gloves, clean up all spills immediately to avoid contamination, use stainless steel or plastic tools and containers, and remember that photographic chemicals are dangerous. Make sure your darkroom is well ventilated and keep children out. When mixing solutions, avoid splashback by placing the water in the container first and then adding the chemicals. As each solution is mixed, store it in a light-proof jug, and immediately label it with the following information: type of chemistry, what step it is in the process, the date prepared, and (later) how many rolls of film have been processed in it.

KODAK FLEXICOLOR C–41 PROCESS

The Kodak Flexicolor C–41 process was the first system designed to work with modern color films, particularly Kodacolor II, Kodacolor 400, and Vericolor II. It is the standard by which other manufacturers' processes are judged.

Preparing the chemistry. The chart on page 37 details how to mix the chemistry for a 16-ounce C–41 kit. Note that steps 3 and 5 are water rinses, so no chemistry is necessary.

Processing the film. The C–41 process is temperature sensitive, so it is important to maintain the correct tempera-

MIXING KODAK FLEXICOLOR C-41
Amounts are for one 16-ounce kit. All temperatures in Fahrenheit.

Step	Chemical	Temperature	Instructions
1	Developer	80-90° F	Start with 11 oz. water. Stir in Part A; stir in Part B. Add water to make 16 oz. Pour into jug, label, cap, and set into water bath of 100° F.
2	Bleach	80-90°	Start with 11 oz. water. Stir in powder A; stir in powder B. Add water to make 16 oz. and stir well. Pour into jug, label, cap, and set into water bath of 100°.
3	Water rinse		
4	Fixer	70-80°	Start with 11 oz. water. Stir in liquid. Add water to make 16 oz. Pour into jug, label, cap, and set into water bath of 100°.
5	Water rinse		
6	Stabilizer	70-80°	Start with 11 oz. water. Stir in liquid. Add water to make 16 oz. Pour into jug, label, cap, and set into water bath of 100°.

tures during processing. The developer is temperature critical; it *must not* vary more than one-quarter degree from 100° F. Although not recommended, the bleach, fixer, and stabilizer can vary as much as 30° F. You should keep all chemistry, including water rinses, within five degrees of each other. The chart on page 38 explains the steps for processing color negative film, including times for each step and agitation. Note that because the developer is quite warm, the actual development time is relatively short.

PROCESSING CAPABILITIES

The standard 16-ounce C–41 developing kit can process between 6 and 10 rolls of film, depending on the size of the roll and the number of exposures. The bleach, fixer, and stabilizer can process many more rolls of film than the equivalent amount of developer. As the developer approaches exhaustion, the development time must be increased to compensate, as shown in the chart on page 39. Although the compensated development times suggested here will be satisfactory for most films, you may have color contrast problems with some emulsions, especially if they are not manufactured by Kodak. Some trial-and-error testing on your part may be necessary.

STORAGE OF C–41 CHEMISTRY

Unused or partially used chemistry can be stored for use at a later date. For maximum effectiveness, store solutions in tightly closed, dark-brown containers, and keep them in a cool place away from direct light. To prevent oxidation from contact with the air, fill the container to the top with the solution, or use the new type of container that allows you to squeeze out the air. C–41 kits are designed to be used and discarded, not

PROCESSING STEPS FOR KODAK FLEXICOLOR C-41

Step	Chemical	Time	Temperature	Agitation	Comments
1	Developer	3¼ mins.	100° F ± ¼°	Continuous for first 30 secs.; 5 secs. every 30 secs. thereafter.	
2	Bleach	6½ mins.	75-105°	Continuous for first 30 secs.; 5 secs. every 30 secs. thereafter.	
3	Water rinse	3¼ mins.	75-105°		Rinse in running water. Fill and then empty 4 times. Keep water temperature within 5° of chemistry.
4	Fixer	6¼ mins.	75-105°	Continuous for first 30 secs.; 5 secs. every 30 secs. thereafter.	
5	Water rinse	3¼ mins.	75-105°		Rinse in running water. Fill and then empty 4 times. Keep water temperature within 5° of chemistry.
6	Stabilizer	1½ mins.	75-105°	Continuous for first 30 secs.	
7	Hang to dry	15-20 mins.	—		Hang in dust-free area.

stored. Unless the chemicals are used within a specified time after mixing, they must be discarded. The chart at right on this page lists the maximum storage periods for C–41 chemicals. Do not use outdated or exhausted chemicals.

If you process a lot of film on a regular basis, it may be more economical, though more complex, to use a replenishment system. (For more information about establishing a replenishment system, see Kodak publication Z–121, *Using Process C–41*.)

STORING C-41 CHEMICALS

Chemical	Maximum Storage Time
developer	6 weeks
bleach	indefinitely
fixer	8 weeks
stabilizer	8 weeks

EVALUATING COLOR NEGATIVES

Color negative film is difficult to evaluate. The negatives have an overall red-

PROCESSING CAPABILITIES OF ONE 16-OUNCE KODAK C-41 KIT

Film Size	Capacity	Time Compensations
126 20 exposures	8 rolls	roll 1 and 2: 3 minutes 15 seconds roll 3 and 4: 3 minutes 19 seconds roll 5 and 6: 3 minutes 24 seconds roll 7 and 8: 3 minutes 30 seconds
135 20 exposures	10 rolls	roll 1 and 2: 3 minutes 15 seconds roll 3 and 4: 3 minutes 18 seconds roll 5 and 6: 3 minutes 22 seconds roll 7 and 8: 3 minutes 28 seconds roll 9 and 10: 3 minutes 34 seconds
135 36 exposures	8 rolls	roll 1 and 2: 3 minutes 15 seconds roll 3 and 4: 3 minutes 23 seconds roll 5 and 6: 3 minutes 28 seconds roll 7 and 8: 3 minutes 33 seconds
120, 620	5 rolls	roll 1: 3 minutes 15 seconds; add 5 seconds for each roll thereafter

orange cast because of the color couplers left in the film to provide color correction and contrast control during printing. As in a black-and-white negative, the image is reversed. Colors are represented by their complements: red is represented as green, yellow as cyan, and green as magenta. The magenta color is almost impossible to distinguish through the red-orange masking system. Neutral colors and pastel tints are also very hard to distinguish.

Because it is so difficult to evaluate a color negative, color balance and processing errors may not be evident until the negative is printed. This is why contact sheets and test prints are so vital for analysis.

What can be evaluated in the negative without much trouble is its exposure and density. Place the negative on a light box. A negative that is either underexposed or underdeveloped will seem thin, with shadow areas that appear clear and with little detail. If the negative also seems very flat, it was probably under-developed, either in a developer that was too cold or because it was not developed for long enough. A negative that is very dark and dense, with blocked-up highlights, is either overexposed or overdeveloped (or both). If the negative also seems very contrasty, it was probably overdeveloped. Use the chart on page 40 to find suggested solutions to specific problems.

When viewing the negative on a light box, the orange-red masking system can be very distracting. Try placing a green filter under the negative. The green filter will subtract red and make the negative seem more like a conventional black-and-white one.

COLOR NEGATIVE PROCESSING PROBLEMS

The most common faults in color film processing are usually caused by errors in the developer temperature. Sometimes chemical contamination, insufficient agitation, or air bubbles can cause problems as well. Use the chart on page 40 to

COLOR NEGATIVE PROCESSING PROBLEMS

Problem	Cause	Solution
Round, pale spots on negative	Air bubbles on film during development	Agitate carefully; tap tank to dislodge air bubbles
Uneven streaking at the edges of the film	Insufficient agitation during development	Follow agitation instructions carefully
Streaking on the surface of the film	Fixer not completely removed during wash cycle	Rewash film
Partial reversal of image; dark, uneven appearance	Film was exposed to light during development and fogged	Do not use safelight while loading film; do not open tank before fixer stage
Negative very contrasty or very dense	Overdevelopment due to: developer temperature too high; overagitation during development; too much time in developer	Monitor temperature, agitation, and time very closely
Negative very flat, soft, or thin	Underdevelopment due to: developer temperature too low; insufficient agitation; exhausted developer; too little time in developer	Monitor temperature, agitation, and time very closely

find suggested solutions to specific problems, and remember that most problems can be avoided by controlling the process tightly.

CARE AND STORAGE OF NEGATIVES

To maximize the life of color negatives and keep their dyes from fading, store them properly:

• Protect negatives from light.
• Store negatives in a cool, dry place.
• Keep negatives clean, free from dust and fingerprints.
• Store negatives in archival-quality negative pages or envelopes. Do not use holders that contain PVC (polyvinylchloride) or residual solvents. They will speed up deterioration.
• Avoid pressure on stored negatives. Do not stack them against each other.

COMPARISON OF C–41 SYSTEMS

Several manufacturers other than Kodak make the equivalent of Kodak Flexicolor C–41 kits. All are judged by the Kodak standard, but their major selling points are greater ease of operation and less critical temperatures in the developing stages.

Three common brands are Kodak Flexicolor C–41, Beseler CN2, and Opticolor. The discussion below will look at the important features of each. Most processing errors occur during the development stage, so that aspect will be given emphasis.

Kodak Flexicolor C–41. The problem of maintaining critical chemical temperatures is what frightens many photographers away from color processing. Despite being temperature-critical to within

a quarter of a degree, this system remains the most popular because of its excellent overall quality.

Beseler CN2. This system is more flexible, and offers a choice of three different processing temperatures: 75° F, 86° F, and 100° F. At 75° the development time is 16 minutes, total processing time 34 minutes, and the temperature latitude is ±1°. The most popular processing temperature seems to be 86°. At 86°, the development time becomes a comfortable 8 minutes, and the latitude is still ±1°. The total processing time is 22 minutes. For short processing times you have the option of working at 100°. The development time drops to 3¼ minutes with a total running time of 13¼ minutes. The temperature latitude of the chemistry also drops at that temperature to one-half degree in either direction. At the short developing time, errors in temperature or time can be magnified, showing up as under- or overexposure or a coarsening of the grain structure.

Opticolor. Manufactured in England, this system also offers variable temperature control, with a choice of 85° F or 100° F. The development times are shortish: 6½ minutes at 85° F and 3¼ minutes at 100° F. To help keep the developer temperature stable, the system uses a water presoak.

HOW COLOR TRANSPARENCY FILMS WORK

The structure of color transparency films is similar to that of color negative film. Both films consist of three emulsion layers that record the primary colors red, green, and blue. The similarity ends there, however.

Processing color transparency film begins with the first developer. This solution forms black-and-white negative images in each of the three emulsion layers. Wherever the emulsion has reacted to light, black silver is formed. After this, the film is fogged by a reversal bath.

This has the same effect as reexposing the film to light: all previously unexposed areas are now fogged. In the next step, color development, the fogged areas created by the reversal bath are developed, becoming black silver. At the same time, the color couplers in the film create positive dye images in the emulsion layers; the images are in the complementary colors of the original image. In the bleach and fixer stages that follow, the black silver is removed, leaving the dyes. The dyes in each layer appear only where the emulsion did *not* react to light in the original scene. The positive dye images are stacked on the film and appear as one image when light is transmitted through the slide. A water rinse and stabilizer complete the process.

When you view the slide, each dye layer removes the unwanted light of one primary color. As the light passes through the exposed areas of the yellow layer, the blue portion is subtracted; the magenta layer removes unwanted green light, and the cyan layer removes unwanted red light. Thus, when the light is transmitted through the transparency, the original colors are seen.

THE E-6 PROCESS

The E-6 process is designed to work with Kodak Ektachrome films and the equivalent films from other manufacturers. Depending on the kit manufacturer, the process has up to 12 steps from first developer to dry. A major advantage of the E-6 process is that you can push or pull (over- or underdevelop) to correct for under- or overexposure or for creative effects.

Of all the E-6 kits currently available, the Beseler kit is probably the best and easiest to use. It has fewer steps than the Kodak kit, costs about the same, and is widely available.

Preparing the chemistry. Follow the same precautions mentioned earlier when mixing chemicals. The chemicals

for E-6 kits are usually in liquid, not powder, form. Stir carefully and make sure that no globules of chemicals remain floating in the solution. See the chart below for details on mixing the chemistry for a one-liter (34 ounces) Beseler E-6 kit. Steps 2 and 8 are water rinses, so no chemistry is necessary.

Processing the film. The first three steps of the E-6 process — the first devel-

MIXING BESELER E-6 CHEMISTRY
Amounts are for a one-liter (34 ounces) kit. All temperatures in Fahrenheit.

Step	Chemical	Temperature	Instructions
1	First developer	100°F ± 1° F	Start with 600 ml (20 oz.) water. Add 1 bottle (200 ml) concentrate. Add water to make 1 liter (34 oz.). Pour into jug, label, cap, and set into water bath of 100° F.
2	Water rinse		
3	Reversal bath	92°-102°	Start with 600 ml water. Add 1 bottle (100 ml) concentrate. Add water to make 1 liter. Pour into jug, label, cap, and set into water bath of 100°.
4	Color developer	100° ± 2°	Start with 600 ml water. Add 1 bottle (200 ml) Part A concentrate; add 1 bottle (50 ml) Part B concentrate. Add water to make 1 liter. Pour into jug, label, cap, and set into water bath of 100°.
5	Conditioner	92°-102°	Start with 600 ml water. Add 1 bottle (200 ml) concentrate. Add water to make 1 liter. Pour into jug, label, cap, and set into water bath of 100°.
6	Bleach	92°-102°	Start with 400 ml (14 oz.) water. Add 1 bottle (400 ml) Part A concentrate; add 1 bottle (40 ml) Part B concentrate. Add water to make 1 liter. Pour into jug, label, cap, and set into water bath of 100°.
7	Fixer	92°-102°	Start with 600 ml water. Add 1 bottle (200 ml) concentrate. Add water to make 1 liter. Pour into jug, label, cap, and set into water bath of 100°.
8	Water rinse		
9	Stabilizer	92°-102°	Start with 600 ml water. Add 1 bottle (40 ml) concentrate. Add water to make 1 liter. Pour into jug, label, cap, and set into water bath of 100°.

oper, the first water rinse, and the reversal bath—must be performed in total darkness. Once the reversal bath is complete, you may remove the lid from the tank and work in room light. The first developer is temperature-critical to within one-half degree. The second developer is temperature-critical to within one degree. The other chemicals can vary up to 10° F, but it is best to have all solutions stabilized at 100° F. The chart below explains the steps for processing color transparency film using the Beseler E-6 process, including times for each step and agitation.

PUSH AND PULL PROCESSING WITH E-6

Under- or overexposure in transparency films, whether deliberate or accidental,

PROCESSING STEPS FOR BESELER E-6

Step	Chemical	Time	Temperature	Agitation	Comments
1	First developer	6½ mins.	100° F ± ½°F	Continuous for first 15 secs.; 5 secs. every 30 secs. thereafter	
2	Water rinse	2 mins.	92°-102°	Continuous	Fill and drain 4 times
3	Reversal bath	2 mins.	92°-102°	First 15 secs. only	
4	Color developer	6 mins.	100° ± 1°	Continuous for first 15 secs.; 5 secs. every 30 secs. thereafter	
5	Conditioner	2 mins.	92°-102°	First 15 secs. only	
6	Bleach	6 mins.	92°-102°	Continuous for first 15 secs.; 5 secs. every 30 secs. thereafter	
7	Fixer	4 mins.	92°-102°	Continuous for first 15 secs.; 5 secs. every 30 secs. thereafter	
8	Water rinse	4 mins.	92°-102°		Rinse in running water
9	Stabilizer	30 secs.	88°-102°	First 5 secs. only	
10	Hang to dry	15-20 mins.	—		Hang in dust-free area

can be corrected in the darkroom by varying the processing time in the first (black-and-white) developer. All the other times remain the same. With film that has been underexposed by one stop, the development time is increased by about 30 percent (2 minutes added to the Beseler developing time of 6½ minutes). There will be a slight increase in both grain and contrast, but the results are still of high quality, and well worth doing. If the film has been two stops underexposed, development time must be increased by about 75 percent (5 minutes added to the Beseler developing time of 6½ minutes). At this point the results are very grainy, there is a significant increase in contrast, and the highlights tend to burn out.

Pull processing, or decreasing the development time for film that has been overexposed, provides only moderately good results. The transparencies will seem a bit flat, with weak colors. In general, a one-stop overexposure requires a decrease in development time of 25 to 30 percent (in the Beseler system this represents 2 minutes).

Push and pull processing can be used for creative purposes. For subtly increased color saturation and contrast, deliberately underexpose by one-third to one-half *f*-stop, and overdevelop slightly by about 10 percent. Gross overexposure and extended development will produce pale, pastel colors and heightened grain structure.

CLIP TESTS

Because E—6 development times can be varied to compensate for exposure errors, a method known as the clip test is used to make sure the variation is correct. To do a clip test, cut off four or five frames from the start of the roll and develop them first. Based on an evaluation of the clip, the rest of the development can be adjusted accordingly. Of course, this method will work only if the

exposure is consistent throughout the roll. If you know you will be doing a clip test, shoot the first frames of the roll with that in mind.

PROCESSING CAPABILITIES

The standard one-liter Beseler E–6 processing kit can process anywhere between 8 and 36 rolls of film, depending on the film size and number of exposures. The bleach, fixer, and stabilizer can process many more rolls, but the crucial first developer has a much shorter capacity. Use the chart below to determine the developer's capacity for the film you are processing. After processing half the maximum amount, increase the time in the first developer to 7 minutes.

PROCESSING CAPABILITIES OF A ONE-LITER BESELER E-6 KIT

Film Size	Capacity
110	36
126 20 exposures	16
135 20 exposures	12
135 36 exposures	8
120, 620	8
220	4

STORAGE OF E–6 CHEMISTRY

As with C–41 chemistry, E–6 kits are designed to be used and discarded at one sitting. However, the chemistry can be stored for later use. Follow the same procedures as for storing C–41 chemistry (see page 38). If tightly closed, opened but undiluted E–6 chemicals have a shelf life of two to three months. Partially used chemistry can be stored for up to four weeks. If the developer turns brown, it should be discarded.

COMPARISON OF E–6 SYSTEMS

The three most popular E–6 processing kits are manufactured by Kodak, Beseler, and Unicolor. All three kits produce

transparencies of high quality. They differ in ease of operation, temperature control, number of steps, and time from start to finish.

Kodak's E-6 processing kit, with a total of nine steps in 37 minutes, is both the longest and most costly of the three systems. It produces results that are very close to those from Kodak professional labs. A pint of Kodak E-6 chemistry will process eight 36-exposure rolls of 35mm film. The kit is sufficient for two pints of both the first and color developers. After developing four rolls, discard the used developers and mix fresh developer chemistry for the next four rolls. This system of fresh developer chemistry, as compared with replenished or reused developer, is what gives Kodak E-6 its consistently clean, crisp quality.

The Beseler one-liter E-6 processing kit will also process 8 rolls of 35mm film. It is a 9-step processing system with a total processing time of 33 minutes. The instruction sheet is well-written and easy to follow, with a step-by-step guide as an aid. Both the first and color developers require strict maintenance of temperature. Variations in temperature can cause underdevelopment or a moderate bluish color shift.

Unicolor manufactures two different E-6 processing kits: standard and rapid. The standard processing kit has a total of 10 steps, which take 27 minutes to complete. This kit is available in quart sizes, which will process 8 rolls of 35mm film. For photographers who shoot large-format negatives, this makes a lot of sense, since a quart or more of liquid is often needed to fill the larger developing tanks. Unicolor's rapid processing kit takes only 24 minutes from start to finish, with only 3 processing steps. Available in pint sizes only, it has the same temperature requirements as the standard kit. Occasional water spotting may occur. This can easily be eliminated by treating the film with a wetting agent.

COLOR TRANSPARENCY PROCESSING PROBLEMS

Problems in processing color transparencies are usually the result of temperature problems in the first developer and/or the color developer. Control the temperatures carefully! Avoid chemical contamination and exhausted solutions. Also be sure to time the steps carefully and to agitate correctly. The chart on page 48 gives suggested solutions to specific problems.

COLOR PRINTING PAPERS

Color printing papers consist of three emulsion layers, much the same as color films. Each layer contains silver halides that are sensitized to one of the three primary colors (red, green, and blue) plus color couplers to form the dye images. The emulsion layers are separated by gelatin layers and are coated onto a white paper base. The paper is sealed by a thin coating of resin (resin-coated or RC paper). The resin coating allows the paper to soak up minimal but adequate amounts of solution, thus speeding washing and drying times.

During the development of the paper, three positive images are formed, each containing a specific dye plus silver. In the red-sensitive layer, cyan dye is deposited where the latent image of red was formed; magenta dye is deposited in the green-sensitive layer, and yellow is deposited in the blue-sensitive layer. During the bleaching and fixing stages, the silver is bleached out, leaving the color images.

The best known and most widely available color printing papers are Ektacolor 74 and Ektacolor 78 RC, both manufactured by Kodak. Ektacolor papers are designed to work with Ektaprint chemistry, also manufactured by Kodak. Beseler, Unicolor, and Parcolor have designed their chemical systems to be compatible with Kodak. (In addition to Ektacolor

printing papers, Kodak also makes Ektaflex film and paper—see chapter 5.)

Ektacolor 74 and Ektacolor 78 RC are medium-weight papers. They are offered in glossy (F), semimatte (E), smooth luster (N), and silk (Y) surfaces. Ektacolor 78 has higher contrast and stronger color density when compared to Ektacolor 74 paper.

Ektacolor papers are sensitive to all colors, and should be handled in total darkness. If that is not possible, use a #13 (amber) safelight with a 7½-watt bulb for no more than three minutes. Too long an exposure to the safelight will cause a blue fog that will be evident in the white borders of the print.

All color printing papers require refrigeration to protect them from heat and humidity. Continued storage at room temperature or temperatures above 50° will alter the color balance. Seal the paper well, folding the foil-lined envelope inside the packet twice to keep out moisture. Paper that has been refrigerated will require three hours to warm up; condensation will form on cold paper. For best results, do not open the paper packet until the warm-up time has elapsed.

Color printing paper must be handled carefully to avoid finger marks, kinks, and smudges. It is a good idea to remove (in total darkness) several sheets from a fresh box of paper and store the remainder of the box away from potential accidents. Remove enough paper for one printing session, store it in a light-tight box or envelope, and keep it easily accessible.

When exposing a sheet of paper, the emulsion side of the paper should face the enlarger light (emulsion-side up). Determining the emulsion side in the dark is occasionally tricky. The emulsion side of an F emulsion feels smooth and slightly slick. It is difficult to tell the emulsion side from the base side on N and E surfaces by feel alone. All print-ing papers curl slightly toward the emulsion side, which is darker and appears almost gray. It can be identified under the appropriate safelight.

PROCESSING COLOR PAPER

In the home darkroom there are four different methods that can be used to process color printing papers: tray, drum, machine (small roller transport or laminar flow), or diffusion transfer. Tray and drum processing are the most common, and will be discussed here. Machines are usually used when processing time and volume become important factors; diffusion transfer (see chapter 5) is where technology is taking us.

DRUM PROCESSING

A light-tight processing drum is a simple, almost foolproof method, with all these advantages:

• All processing can be done in room light, allowing for good time and temperature control.

• Solution temperatures remain fairly stable during processing.

• There is minimal physical contact with the chemistry.

• The emulsion side of the print is protected from handling.

There are also disadvantages to the drum method. Only one or two prints can be processed at the same time, and chemical contamination can cause streaking or staining. Processing drums really require a motor base, since uneven agitation due to hand rolling will create mottled, uneven prints.

Drum processing step-by-step. Premix the chemistry, and set it in a water bath until it reaches the correct processing temperature. Expose the paper normally. Load the paper into a clean, dry processing drum in total darkness. The back of the paper should touch the wall of the drum, with the emulsion side of the paper facing inward. Loading the drum backward will cause streaking, since the

chemistry will be unable to coat the emulsion evenly. Many drums have built-in ridges to aid in loading. After the drum is tightly capped, the remaining steps may be done in room light. Follow the processing steps, times, and temperatures outlined by the manufacturer of the system you are using.

A one-half to one-minute water presoak before development can be added to all processing systems to prevent streaking or uneven development. The temperature of the water is critical — it must be the same as the developer. Agitate continuously during the presoak.

After the chemicals are poured into the drum opening, agitation must be started immediately. Any delay will cause the chemistry to remain in one spot too long, and will cause uneven streaks. Begin draining the chemicals 10 seconds before the processing time is over. Be certain all chemistry is removed before adding the next chemical step. When in doubt, or as a precaution, a water rinse step may be added.

Follow time and temperature recommendations accurately. Fluctuations in temperature, either during a step or from step to step, will cause color variations. Should problems come up, see the chart on page 47 for possible causes. *The Beseler two-step system.* The Beseler two-step system requires only two chemical solutions: the developer and the bleach-fix (blix). It is very simple to use. Simply mix the developer, mix the bleach-fix, bring both up to working temperature, and stabilize in a water bath. Expose the paper, and then load it into the drum in total darkness. Consult the instruction sheet that comes with the kit and choose a time and temperature combination. Beseler offers 15 different possible combinations, from 107° F with a development time of one minute to 66° F and a development time of 10 minutes. The most frequently used combination is 86° F with 3½ minutes

of development; the chart on page 47 uses that combination as an example.

TRAY PROCESSING

Tray processing requires little investment, and allows a number of prints to be processed at the same time. Its chief drawbacks are the difficulty of maintaining accurate temperatures, the need to work in total darkness, and longer development times (necessary to decrease the margin of error). Most advocates of the tray system are experienced black-and-white printers who find this system more comfortable. Working with trays requires additional handling of chemistry. Be sure your darkroom is ventilated.

To its advantage, streaking and staining are virtually eliminated in the tray method. If a standardized procedure is followed at all times, the prints will be amazingly consistent and uniform in quality.

A water bath is necessary to avoid fluctuations in temperature. However, Beseler, as well as Unicolor and Parcolor, offers a time-temperature chart for ambient temperature processing. If the temperature of the room is 70° F, the temperature of the tray solutions will also stabilize at 70° F. This temperature requires a development time of 8 minutes, and a bleach-fix time of 2½ minutes.

Tray processing with the Beseler two-step system. Mix one quart of developer and one quart of bleach-fix. Pour the developer and the bleach-fix into separate trays, and allow them to settle to room or ambient temperature.

Consult the time-temperature chart for the processing times. Using tongs or rubber gloves, completely submerge the exposed paper in the developer solution, face down. Agitate continuously during the entire development time. Avoid potential contamination from splashing chemicals, and don't damage the soft emulsion side of the paper through care-

PROCESSING STEPS FOR THE BESELER TWO-STEP SYSTEM
The instructions here assume a solution temperature of 86° F and drum processing.

Step	Chemical	Amount	Time	Instructions
1	Water presoak	To cover	1 min.	Agitate normally.
2	Developer	3 oz. per 8 × 10 print	3½ mins.	Agitate continuously. After 3 mins. 20 secs., drain drum, shaking vigorously.
3	Water rinse	As needed	As needed	This step is needed if localized blue stains appear on print; the rinse aids in full removal of developer.
4	Bleach-fix		1½ mins.	Agitate normally; begin draining drum after 1 min. 20 secs.
5	Water wash	As needed	2½-5 mins.	Wash in running water. Do not exceed recommended washing time or emulsion may become overly soft; paper may become waterlogged and puffy.

TROUBLESHOOTING CHART FOR BESELER TWO-STEP PROCESSING SYSTEM

Problem	Possible Causes
Uneven development	Not enough developer used. Paper loaded incorrectly into drum. Inconsistent or uneven agitation. Agitation not started immediately during development step.
Localized blue streaks or stains	Insufficient draining of developer and subsequent contamination of bleach-fix. Agitation not started immediately during bleach-fix step.
Pinkish cast over entire print	Serious contamination of bleach-fix by developer. Mix fresh chemicals.
Yellow or red areas	Paper light-fogged

less handling. Ten seconds before the end of the development, drain the paper, then immerse it completely, face down, in the bleach-fix. Agitate continuously for the recommended length of time. The lights may be turned on after 30 seconds of this step have elapsed. Wash the print in running water for the recommended time, and be sure to dry it completely before attempting to make any assessments.

If streaking occurs, due to inadequate drainage of the color developer and subsequent contamination of the bleach-fix, a water rinse between these steps may be added.

A quart of chemistry should enable you to process 25 8×10 prints, when used as directed. Beseler has both a reuse and a replenishment system for maximizing the number of prints that may be processed.

COLOR TRANSPARENCY PROCESSING PROBLEMS

Problem	Cause	Solution
Overall image too dark, with oversaturated colors and a slight red-magenta color cast	Inadequate first development due to: insufficient time in developer; diluted or exhausted developer; temperature too low; inadequate agitation	Check time carefully or do a clip test; mix chemistry carefully; discard stored chemistry when in doubt; monitor temperature carefully; follow recommended agitation
No image; entire roll black	First developer and color developer reversed; first developer omitted; film never exposed	Label all containers accurately; post developing chart and follow it step by step; check camera and method of loading film
Film too light overall	Overdevelopment due to: too long in developer or developer temperature too high; first developer too concentrated or overreplenished. First developer contaminated; overexposure in the camera	Monitor time and temperature carefully; label containers carefully; meter carefully, bracket or do clip test.
Film too light overall with a blue color cast	First developer contaminated with fixer	Be careful in your work habits
Film completely clear	Film fogged by light before developing; film developed with fixer in first step	Load film in total darkness; monitor work habits and label containers
Colors very pale with slight blue or cyan color shift	Too little color development due to: insufficient time in color developer; temperature too low; diluted or exhausted developer	Monitor time and temperature more carefully
Yellow color shift	Color developer added to first developer	Monitor work habits
Green color shift	Reversal bath exhausted or diluted	Discard old chemistry; follow mixing instructions

PROBLEM: weak, flat image; colors dull and lifeless.
CAUSE: the film was overdeveloped, either by too much time in the first developer or by first developer that was too warm.

PROBLEM: dark, contrasty images.
CAUSE: the film was underdeveloped, either by too little time in the first developer or by first developer that was too cold.

PROBLEM: film has odd tonalities, with green highlights.
CAUSE: the color developer was contaminated with bleach-fix.

PROBLEM: film is light with a blue color cast.
CAUSE: the first developer was contaminated with bleach-fix

PROBLEM: overall green cast.
CAUSE: the reversal bath was exhausted or chemically contaminated.

PROBLEM: dark image that changes and darkens over time.
CAUSE: fixer omitted from development process.

PROBLEM: unusual purple tonality over part of the image.
CAUSE: the film was exposed and not developed until years later.

COMMON E-6 PROCESSING ERRORS
The photographs on these pages illustrate E-6 processing errors. Although these shots were made using the Beseler E-6 process, similar results would be obtained using any manufacturer's process.

3

Printing Color Negatives

THE GOAL OF COLOR DARKROOM WORKERS IS to see great prints in the shortest possible time. But a lot of variables have to be controlled in color printing, and there are no shortcuts to quality.

THE VALUE OF A SYSTEM

The system outlined below will help you organize your printing sessions efficiently, and will provide the maximum of information with the minimum of work. It will save you the time and money otherwise wasted on poor prints.

To make systematically good prints, you should make a contact sheet, a test print, and first print. You will also need a good standard negative for comparative purposes, and data sheets to record information. The information you obtain along the way will be used to create the final print.

STANDARD NEGATIVES

Because so many variables are involved in color printing, you need a reference point to help organize all the information. Standard negatives make ideal references. A good standard negative is correctly exposed and contains a gray card, a set of color test patches or a broad range of colors, and flesh tones. When you print your contact sheets, include the standard negative for comparison. This will give you important information about density, contrast, exposure, and filtration, and will eliminate unnecessary test prints.

Standard negatives can be purchased or made yourself. Commercial standard negatives, such as those produced by Kodak, are often called "Shirleys" because they usually contain portraits of smiling, pretty, but bland young women.

The *Kodak Color Data Guide* contains a "Shirley" shot on Vericolor II Professional S film.

Alternatively, you can shoot your own standard negatives. Include in the scene the gray card and color test patches included in the *Kodak Color Data Guide*. Shoot scenes that are relevant to the type of photography you prefer—if you do a lot of landscapes, don't shoot a portrait for your standard negative. In general, look for a situation that has a broad range of tones and is evenly lit. Avoid scenes with hot spots and glare. While you're shooting, do a series of standard negatives, using varying films and light sources. You'll create a valuable, personalized system that way.

CONTACT SHEETS

Color negatives are difficult to interpret. In addition to presenting a reversed image, the orange mask further obscures information. A contact print, however, provides a great deal of information, including content, composition, exposure density, contrast, color bias, and sharpness. Contact sheets are also useful for filing and retrieving your images.

Making a contact sheet is relatively simple. Lay strips of negatives on the color photographic paper, either in a contact printer or under glass; expose, and then process.

It is a little trickier to make a contact sheet with the right color balance and exposure. However, once you find the correct information, it can be transferred almost directly onto the print. This is where the standard negative becomes important. The gray scale in the image becomes the reference point. Since you know from it what 18% gray

PRINTING DATA SHEET

Contact Sheet Information

Date: Contact Sheet #:
Film Type: Paper Type:
Processing:
 f-stop: time:
 filtration: M: C: Y:

Printing Information

Date	Frame #	F-Stop	Time	Filtration	Paper	Magnification	Comments

should look like, you can expose for that tone. The color test patches are the information source for the density, saturation, and color shift. Since the standard negative tells you what normal is, variations from the norm can be seen immediately. This enables you to begin your test prints with an educated guess about the correct exposure and filtration information.

MAKING A CONTACT SHEET

In preparation for making a contact sheet, mix the chemical solutions and bring them up to working temperature in a water bath. Clean the contact printer or glass well, and place an empty negative carrier in the enlarger head. Adjust the head of the enlarger so that the light beam fully illuminates the contact printer. Focus the light until the edges appear crisp. For the best conversion information, set the height of the enlarger so that the rectangle of light is the size you will be printing the image. There will thus be only slight exposure changes (due to the density of the negative and filtration changes) from a contact print to a first print.

In total darkness, or with the appropriate safelight, place the negatives (including your standard negative) and the printing paper in the contact printer. The emulsion side of the negatives should be against the emulsion side of the paper. Make sure all the images face in the same direction, and keep the negatives in numerical order. Expose for 10 seconds at $f/11$. If the contact is very dark, close the lens to $f/16$; if it is very light, open the lens to $f/5.6$ or $f/8$.

Process the paper and allow it to dry thoroughly before deciding on any changes. Evaluate the contact sheet for exposure information first. After a contact of the correct density is reached, filtration changes can be made.

Evaluate and edit the contact, using these educated guesses as starting points for test and first prints. Record all information on data sheets. Negatives tend to be fairly similar in exposure and filtration information, especially when shot on the same film in similar lighting.

File your negatives in 8×10 notebook-style negative pages. Punch holes in the contact sheet and data sheets, and file them in the notebook with the negatives. This system enables you to retrieve negatives, contact sheets, and exposure information all at once at any time.

DATA SHEETS

A calibrated contact sheet is a valuable tool in the darkroom. It functions as a guide to filtration, exposure, and editing

for all the negatives on the sheet. It is also an excellent aid in the storage and retrieval of individual negatives, as well as for recording printing information from prior darkroom experiences. Each contact sheet should have its own darkroom data sheet. The example shown at left is a good model. Train yourself to use a data sheet. Conscientious record-keeping of all essential information will cut down on the waste of expensive printing paper and speed up reprinting.

EVALUATING CONTACT SHEETS

Content. Edit your contacts for content first. Using a loupe and light box, decide which are interesting. Which have strong compositional elements, good color, or unusual details? Lightly mark the frames on the contact that you want to print. Preliminary cropping decisions can also be considered at this point. Use a white or black card, with an opening the size of a single frame in the center, to isolate the image. Masking cards with different size openings can be used to give additional cropping information. Make light crop marks on the contact without destroying the original image.

Sharpness. Next, evaluate the contact for sharpness. If the image is slightly soft (a polite term for out of focus), and

COMMON PROCESSING ERRORS
IN NEGATIVE PRINTMAKING

The photographs on this page and pages 56 and 57 illustrate common processing errors when making prints from negatives.

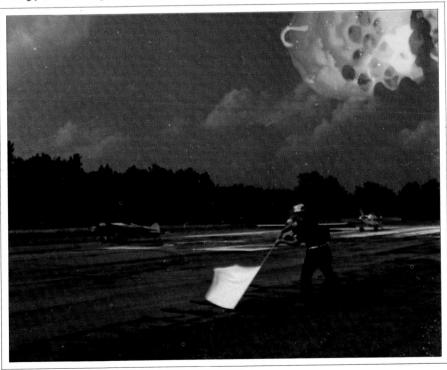

PROBLEM: red fingerprint on print.
CAUSE: paper was touched with wet finger before processing.

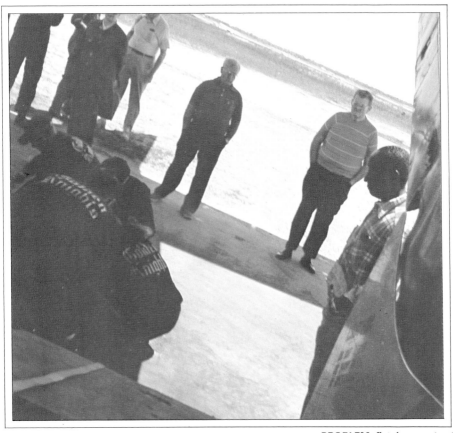

PROBLEM: flat, low-contrast print.
CAUSE: cold developer led to underdevelopment.

PROBLEM: blurry area.
CAUSE: a piece of white paper used for focusing was accidently left on printing easel and covered the printing paper during exposure.

PROBLEM: magenta stain.
CAUSE: exhausted developer.

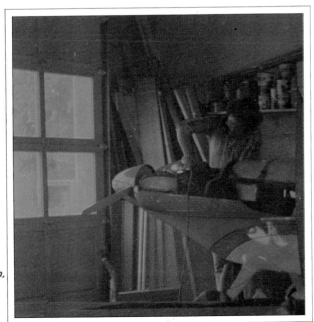

PROBLEM: overall cyan stain,
including print borders.
CAUSE: bleach-fix contam-
ination of first developer or
prewet solution.

if that was not your original intent, it will not handle an enlargement gracefully. Look for the sharpest frame in each shooting sequence. (If your images are continuously out of focus, you may need eyeglasses. The problem could also really be camera shake. Hold the camera firmly at low shutter speeds, or use a tripod.)

Exposure. When the density of your standard negative is correct on the contact sheet, but the rest of your negatives are lighter or darker, you are seeing variations in the original in-camera exposure, which controls negative density. An underexposed negative appears thin. The orange mask is very light, and the negative produces a dark, flat contact print. Very underexposed negatives will yield flat prints with muddy, unsaturated prints, if they are printable at all. You will need to reduce the exposure time or stop down the aperture when exposing.

An overexposed negative appears dark and blocked up, and has a darker orange mask. It produces very light, often contrasty contact prints. Grossly overexposed negatives are often printable, but suffer from increased grain structure. Additional light is needed to cut through the density, so open the lens aperture one or two *f*-stops. Try not to exceed 14 seconds in exposure time, or the printing paper's own reciprocity may become a factor and require additional filtration changes.

If your negatives are continuously over- or underexposed, evaluate your method of metering, or have your camera cleaned and serviced. Inaccurate shutter speeds are often the cause of exposure problems.

Filtration. Assuming that both the exposure and the color reproduction of the standard negative are correct on the contact print, variations in the color rendition of the other color negatives indicate the need to make filtration changes. You can use the new filtration information to make a corrected contact print, or, if your contact is pretty close, use the information to make a high-quality test print. Compare the different frames on the contact. Images close in density and color rendition will enlarge with similar exposure and filtration requirements.

TEST PRINTS

When making a test print, choose a negative that appears to be easy to print. The lighting should not be too contrasty, the original exposure should be correct, and it should be sharp. Compensation printing due to exposure errors can only confuse you, and rarely works. Make a test print as explained below, and evaluate the completely dry test print in bright light before making any changes.

In preparation for making the test print, mix the chemicals, and bring them up to working temperature in a water bath. Clean the negative well, using an antistatic gun and compressed air. If your negatives are especially soiled, use a film cleaner applied with a dust-free cloth. Immediately place the negative in the negative carrier, emulsion-side down, and place the negative carrier in the enlarger head to minimize further contact with dust.

With the enlarger on white light, or with all filters removed, and with the lens wide open, project the image onto a printing easel that contains a sheet of white paper for focusing. Adjust the enlarger to the appropriate height, keeping in mind that not every print is best at a full 8×10 enlargement. If the image is soft, or a bit flat, consider reducing the size of the enlargement.

Set the filtration according to the manufacturer's recommendation, or according to the filtration you used on the contact print. Once you determine the time and filtration for one magnification, it's best to stay there for that session. If not, further exposure changes and slight filtration changes will become

To know how much of an exposure change is necessary to make a correction, it helps to have an idea of what half-stop, one-stop, one-and-a-half stop and two-stop variations from the norm look like. The print above top was exposed correctly at f/16 for 10 seconds. The filter pack, which remained unchanged throughout this sequence, was .50Y .60M. The normal print has good detail in the jumpers, but the background, especially the water, appears a bit bright. The color saturation of the water in the print directly above is much superior because the print was over-exposed by a half-stop, but the jumpers are too dark; the jumpsuits and faces are missing details in some areas, and the road is beginning to show a magenta highlight. Further overexposure at f/11 (top, page 60) and f/8½ (bottom, page 60) gives even less detail in the jumpers. The best exposure for showing facial details is a half-stop underexposed (top, page 61) but the colors of both the jumpsuits and the water are weak and unsaturated. A full stop of overexposure almost obscures the background altogether (bottom, page 61).

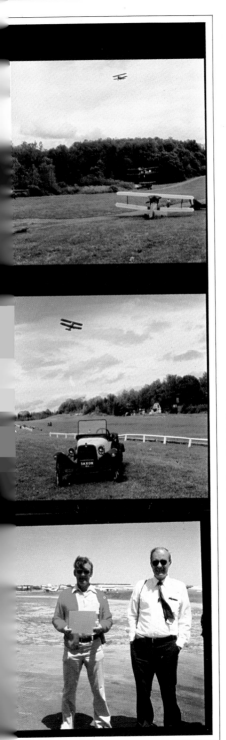

The standard negative (bottom right) on this contact sheet was shot with daylight film at noon on a clear, sunny day, the best time for neutral light. Exposure was based on the gray card held by the man on the left.

The two images directly above the standard negative appear to be of correct density, and also seem fairly accurate in color tonality. The middle strip of negatives demonstrates how a slightly overexposed, dense negative prints if the enlarger aperture is too small for it. The exposure variations in this contact are between one-half and one stop from the standard negative. The house and fence show about a half-stop difference; the woman and child in the road show about a one-stop difference.

The house and flag at middle left show how a thin, slightly underexposed negative appears when compared to the norm. It prints darker, and requires less exposure time (probably one stop) than the standard negative.

Preliminary filtration information is obvious here: all the images on the contact consistently shift to the yellow-green end of the spectrum when compared to the standard negative.

CONTACT EXPOSURE: f/11½ at 10 seconds.
FILTRATION: .65Y .55M

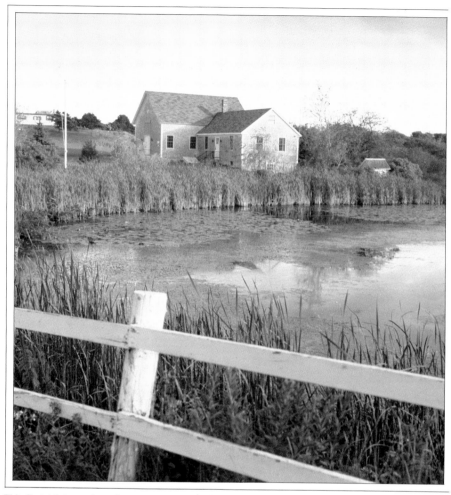

This first print was based on an exposure eval-
uation of the contact print. Since this negative
is slightly denser than the standard by about
one-half f-stop, a half-stop of additional
exposure was necessary to get a print of the
correct density. No changes have been made
in the filtration yet, although the very cyan
bias of the print is obvious in the white fence.
Looking at a white or highlight area of the
print will help you see color biases.

FIRST PRINT EXPOSURE: f/11 at 10 seconds.
FILTRATION: .65Y .55M

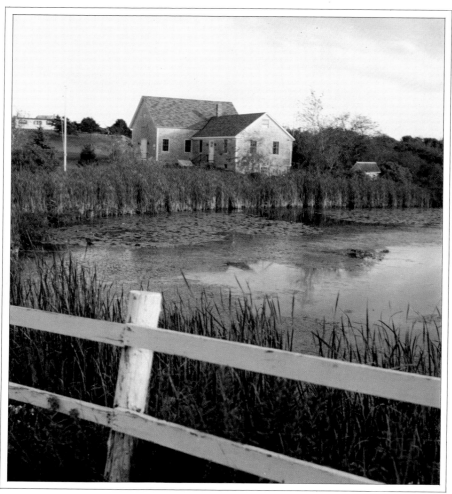

To deal with color filtration changes, a second
print was made. The first print had an excess of
cyan. Rather than add cyan, its complement, red,
was removed. Since red is composed of equal
amounts of yellow and magenta, those two colors
were removed from the filtration pack in equal
amounts ($-.10M\ -.10Y = -.10R$).

SECOND PRINT EXPOSURE: f/11 at 10 seconds.
FILTRATION: .55Y .45M

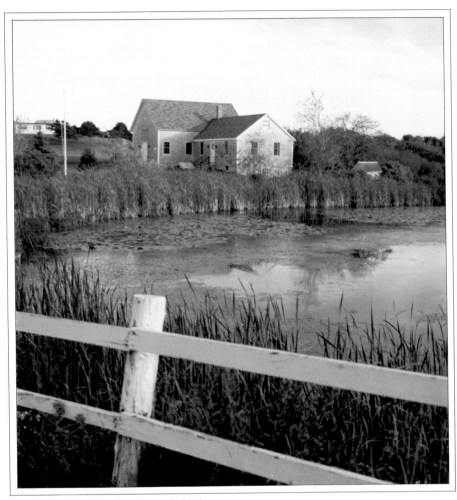

For the final print, the density was judged to be correct. The print was still too greenish, so an additional .10M was subtracted to shift the color more to the blue-purple end of the spectrum. The brown tones now seem warmer, and a faint pink tone is seen in the highlight of the cloud.

FINAL PRINT EXPOSURE: f/11 at 10 seconds.
FILTRATION: .55Y .35M

necessary, which can be very frustrating and time-consuming.

A test print will have four to six separate exposures on the same piece of paper. For maximum exposure information, you can expose the paper on a vertical, horizontal, or even diagonal pattern, depending on the subject matter and the compositional elements of the image. It is more useful to divide an image so that highlight and shadow areas are seen under all the f-stops tested. In addition to obtaining correct exposure information, you will be able to identify preliminary dodging and burning information (see chapter 6).

When making color test prints, the element varied is the f-stop (not the time, as in black-and-white printing). The easiest way to do this is with a proof printer. You can purchase one of the handy proof printers on the market today, or you can make your own by cutting four square openings in a piece of lightweight cardboard. Even more simply, two pieces of cardboard can be moved across the paper, exposing only one portion of it at a time as you adjust the f-stop.

If the negative density appears to be average, make four separate exposures for 10 seconds each at the following f-stops: $f/8$, $f/8\frac{1}{2}$, $f/11$, and $f/11\frac{1}{2}$. If your negative seems thin, cut back the exposure time to five or six seconds, and expose with the lens stopped down as far as possible, to $f/11$, $f/16$, $f/22$, and $f/32$.

If your negative is overexposed or overdeveloped, it will appear quite dense, and need extra light or additional exposure time to print. If your enlarger has a high- or low-light option, set it to high. (Remember to turn it back to low for normal and thin negatives.) You might need to put a brighter bulb into a condenser enlarger, especially if you use a lot of filtration. Make sure to check the manufacturer's specifications for the maximum bulb size for your enlarger.

Make test prints at 13–16 seconds, starting with the f-stop wide open, at $f/2$ or $f/2.8$. If you have a condenser enlarger, use the least number of filters possible, combining filters where you can (see page 73 on combining color filters).

Magnification is an additional variable when considering exposure in test printing. A negative that is enlarged to 8×10 or larger will need additional exposure time, since the light is traveling a greater distance. Conversely, small enlargements will require shorter exposure times, since the light travels a shorter distance.

Evaluate the test print for exposure information, looking at the highlights, shadows, and mid-tones for information. If the color is only slightly off, it will not interfere with density exposure evaluations. A print with an extremely strong color bias, however, may need an extra test print after the initial filtration changes are made. To zero in on the correct exposure, work in between two f-stop settings in half-stop increments. You would then record the stop between $f/5.6$ and $f/8$, for example, as $f/5.6 + \frac{1}{2}$. An alternate method of zeroing in is to add or subtract a few seconds from the exposure time.

EVALUATING FOR COLOR FILTRATION

Before you can correct the color filtration of your print, you must be able to identify the colors you are seeing, especially if there is a bias in a particular direction. Red and magenta are often mistaken for each other. If the print has a reddish-purple cast overall, the color cast is magenta. If the print has a reddish look but no purple cast, the color is red. When compared visually to magenta, red has an orange cast due to the yellow in its makeup. Differentiating between blue and cyan can also be troublesome. Photographic blue has a purple

bias, whereas cyan is more of a blue-green color.

A photograph that is too cyan has too much magenta and yellow or not enough cyan. You can add cyan, but since cyan is rarely used in a negative printing pack, it is preferable to subtract some magenta and yellow. A print with a magenta bias has too much yellow and cyan, or not enough magenta. If the print appears to have too much yellow and too much magenta, it can also be said to have too much red, since yellow and magenta in equal amounts produce red. However, if the yellow and magenta are present in unequal amounts, they will produce various shades of orange, and have to be corrected separately. If all this seems confusing, keep in mind that when printing a negative you are always working with opposites. Add the color that is too strong, or remove its complement.

Color print viewing filters are a useful aid for assessing filtration. In addition to providing specific filtration information, they help train the eye in color discrimination. Of the several sets commercially available, the Kodak filters are probably the easiest to use.

A color viewing filter kit consists of filters in different densities for the primary and secondary colors: red, blue, green, and magenta, cyan, and yellow. View an out-of-balance print through the filters, looking for the filter or filters that correct the color balance. Printed instructions on each filter card tell how to add or subtract from the filter pack. Assuming your viewing choices are accurate, the adjusted filter pack should give you the correct color balance.

MAKING FILTRATION CHANGES

After deciding which color is excessive in the print, that information must be translated into filter pack changes. If the color cast is slight, add or subtract a filter of .05 density. A moderate color cast will require filter changes of .10 density, and a very strong bias will need a filter change of .20 or more for a dramatic change. Your goal should be to get within .05 of the correct filter pack in the test print. With practice you will be able to make fine-tuning adjustments of .025.

The table below is a starting guide for color filtration. Use it as a base for correcting the filter pack used for the test or first print. When working with filtration, it is important to keep the basics of additive and subtractive color relationships in mind. Use the chart on page 73 and the information on pages

FILTER PACK CHANGES

Color Bias of Print	Suggested Filter Pack Changes			
	Small	Moderate	Large	Gross
Blue	−.05Y	−.10Y	−.20Y	−.40Y
Cyan	−.05Y −.05M	−.10Y −.10M	−.20Y −.20M	−.40Y −.40M
	(−.05R)	(−.10R)	(−.20R)	(−.40R)
Red	+.05M +.05Y	+.10M +10Y	+.20M +.20Y	+.40M +.40Y
	(+.05R)	(+.10R)	(+.20R)	(+.40R)
Magenta	+.05M	+.10M	+.20M	+.40M
Green	−.05M	−.10M	−.20M	−.40M
Yellow	+.05Y	+.10Y	+.20Y	+.40Y

Numbers in parentheses are compensations for those using filter packs, not dial-in color-head enlargers.

What color do you see? When red and magenta are visually compared, their differences become obvious: magenta appears almost purple, while red seems almost orange. Photographic blue also has a purple bias because of the magenta in it. Cyan seems almost green in comparison, due to the yellow in its makeup. Correct lighting is essential to assessing prints. Your viewing area should contain adequate, even light, preferably a mixture of balanced daylight and both incandescent and fluorescent lighting. Pure daylight for viewing might make the print seem a bit blue; pure tungsten lighting might cause the print to seem biased toward orange. To create the dramatic color shifts in this photograph, .40 density filters were used. The magenta color of the upper left quadrant was created with a green filter; the red of the upper right quadrant was made with a cyan filter. In the bottom left quadrant, blue was formed with a yellow filter, and in the bottom right quadrant, a red filter formed cyan. To get rid of a color cast, either add more of the color (but eventually neutralize the filter) or subtract its complementary color.

9–17 to make sure you keep these fundamentals in mind.

EXPOSURE ADJUSTMENTS

If you change the filter pack, you will probably need to make exposure adjustments, due to the relative density of the filter and the amount of light passing through it. Use the chart on page 73 to help determine what exposure changes are necessary. The increase or decrease of exposure is given in *f*-stops. Add or subtract in *f*-stops, then convert to time adjustments as needed.

+.40Y

BLUE

+.20Y

NORMAL

+.40M

GREEN

+.20M

BLUE END OF SPECTRUM

The color ringarounds on pages 70 to 76 demonstrate the effects of specific filtration changes when printing from the negative. The ringarounds have been divided into the blue and red parts of the spectrum as an aid in discriminating colors. To correct an excess color cast in a print, add the color you wish to change, or subtract its complement. For example, a photograph that is +.20 too green would be corrected either by adding .20G (Y + C) to the filter pack or by subtracting its complement, −.20M. Magenta viewing filters would help you to see the green correction. If the print is too blue, use a yellow viewing filter to determine the extent of the correction needed, and then sub tract yellow filtration to correct for the blue bias. If the print is too cyan, use a red viewing filter to determine the correction. You could add cyan filtra tion to the pack, but cyan is rarely used in a negative printing pack. Instead, subtract its complement, red (M + Y).

+.40R ────┐
 │
 CYAN │
 │

+.20R ────┘

NORMAL

EXPOSURE ADJUSTMENTS FOR ADDITIONAL FILTRATION
Adjustments are given in f-stops.

Filter Density	Yellow	Magenta	Red	Cyan	Green	Blue
.05	none	⅓ or less	⅓ or less	⅓ or less	⅓	⅓
.10	⅓ or less	⅓	⅓	⅓	⅓	⅓
.20	⅓	⅓	⅓	⅓	⅓	⅓
.30	⅓	⅔	⅔	⅔	⅔	⅔
.40	⅓	⅔	⅔	⅔	⅔	1
.50	⅔	⅔	1	1	1	1⅓

ADDITIVE AND SUBTRACTIVE COLOR RELATIONSHIPS

Additive Colors	Subtractive Colors	Filtration
R = M + Y	M = R + B	M blocks G
G = C + Y	C = G + B	Y blocks B
B = C + M	Y = G + R	C blocks R

ADDING UP FILTERS

When you make filtration changes in your printing pack, you must calculate or add the exposure densities. For example, if your filter pack of .20Y .20M requires filtration changes of + .20Y + .30M, your new filter pack would become .40Y .50M. Your exposure change due to the new filtration would be one-third stop more for the additional .20Y, and two-thirds stop more for the additional .30M. In total, then, one full *f*-stop correction must be made because of the change in filter densities.

If you are stacking filters in a condenser enlarger, you must minimize the number used. If the filtration requires .30M + .70Y, you would require up to six filters in the pack. But since magenta and yellow in equal proportions make red, you could use a .30R filter (.30Y + .30M) along with a .40Y filter instead; this would reduce the number of filters in the pack to two.

Primary color filters cannot be stacked together. One primary filter and one secondary filter may be stacked, if the secondary is part of the primary. If you stack magenta, yellow, and cyan in equal densities, you will get a gray color, or neutral density.

USING THE COLOR RINGAROUND

The color ringaround sequences on pages 70–76 are an aid to making initial evaluations. These sequences are helpful tools for comparison when you make a text print. They are also helpful for training your eyes to detect the necessary color and filtration changes.

MAKING A FIRST PRINT

A first print should be based on exposure determinations only. It's best not to evaluate a test print for both exposure and filtration at the same time, since these are directly related to each other. The tonality at one exposure can be different than the tonality at another exposure. Often a print has a slight blue bias when underexposed, but that bias may disappear at the correct exposure. Filtration changes to correct the bias may thus have been unnecessary, and you then need to correct the new, "corrected" filtration. This is known as chasing around the color, and it is one of the most common mistakes made in the color darkroom. Only after you have determined the correct exposure should you evaluate the print for color and filtration. Follow the chart on page 68 for suggested filter pack changes. It is also a good idea to keep the color ringaround available while you are scrutinizing the print for color filtration changes.

— .40Y

YELLOW

— .20Y

NORMAL

− .40M

MAGENTA

− .20M

RED END OF SPECTRUM

As the ringarounds on these pages and page 76 show, to correct a color cast in negative printing, add the color that is too strong, or remove its complement. If the print shows a yellow color bias, use a blue viewing filter to determine the amount of correction needed. Correct the filter pack by adding more yellow. To determine the correction needed if the print has a magenta cast, use a green viewing filter. Use a cyan viewing filter to find the correction needed for a print that is too red. To correct a red cast, add red (Y + M) to the pack.

— .40R —

RED

— .20R —

NORMAL

This test print of a model was made with .60Y .60M
as the starting filter pack. Exposure was 10 seconds
each at f/8, f/11, f/16, and f/22. After assessing
the test print, a first print (page 78) was made
at f/16 at 10 seconds, with a filter pack of .60Y .60M.
The density of this print seems good, but the tonality
of the model's face is a bit reddish-orange, with
yellow in the highlights. To shift the red tone to the
blue-magenta end of the red spectrum, yellow is
added. The filter pack becomes .70Y .60M. When
adding a filter, the exposure must also change to
compensate for the additional density. Adding
.10Y requires an additional one-third f-stop, or its
time equivalent, 2 seconds. Final print (page 79)
exposure: f/16 at 12 seconds. Filtration: .70Y .60M

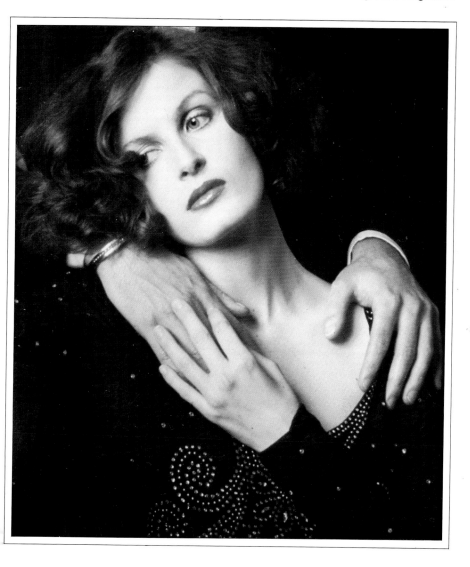

4

Printing
Color Positives

PRINTING FROM COLOR TRANSPARENCIES, OR direct positive printing, can produce results with rich, saturated colors and excellent long-term stability. The process is relatively simple and inexpensive, and requires no equipment other than that found in the standard color darkroom.

CHOOSING A TRANSPARENCY

In direct positive printing it is important to work with transparencies that are moderately low in contrast and that are correctly exposed. A contrasty slide may exceed the tonal range of the paper, producing a print that is very harsh, with little or no detail in the highlight or shadow portions of the image. This sort of slide will require extensive dodging, burning-in, or even masking to reduce the relative contrast and lengthen the tonal range. Avoid using slides that are overexposed, with highlights that are pale and lacking detail. These will produce prints with weak colors and washed-out highlights. An extremely underexposed slide will appear dense, and may have large shadow areas containing important detail. The print it will yield will be dark and richly saturated, but there will be a noticeable loss of shadow detail. These areas may block up, producing large areas of solid black.

Transparencies that are imperfectly exposed or high in contrast can still be printed. Advanced color workers can take a whole range of transparencies and, through interpretive and creative manipulation, produce magnificent prints (see chapters 6 and 7).

By looking at a slide on a light box with a loupe or by projecting it, you can instantly determine its quality. This means that in direct positive printing a contact sheet, though still useful, is not mandatory for evaluating exposure, contrast, color saturation, and filtration. A transparency can be very deceptive, however, and may produce a print that does not meet your expectations. Color transparencies are meant to be viewed by transmitted light; they are then bright, crisp, and contain a wide range of tonal values. The color print, which is viewed by reflected light, reproduces the sense of light in the image differently. Although the print attempts to capture the slide's colors accurately, it cannot always reproduce the tones and details in the slide's light and dark range.

DIRECT POSITIVE SYSTEMS

Direct positive systems fall into two categories: chromogenic and dye-bleach. The chromogenic systems, such as Kodak Ektachrome 14, utilize the same concept of three silver-halide emulsion layers found in other printing papers. The paper is exposed, and during processing color couplers in each layer form a dye complementary to the color sensitivity of the layer it is in. In the dye-bleach system, such as the Cibachrome process, the dyes are incorporated into the emulsion layers during manufacture. During processing, the unwanted dyes in each layer are bleached out. Diffusion transfer systems for the home darkroom are a new development in direct positive printing. For more information about them, see chapter 5. The dye transfer system of printing is probably the best there is, but it is quite complex even for advanced darkroom workers, and will not be discussed here.

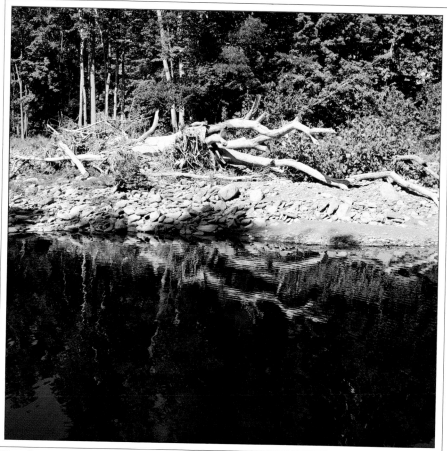

Choosing an accurately exposed transparency will make printing much easier. Transparencies photographed in bright, contrasty light, such as the one above left, will have harsh light and dark areas, and extreme contrast build-up, requiring corrective printing. Incorrectly exposed transparencies should also be avoided. Large areas of under- or overexposure, such as in the picture above, will require tricky dodging and burning-in manipulations. The simplest transparencies to print are evenly lit, moderately low in contrast, and correctly exposed, as in the shot below right.

CHROMOGENIC SYSTEMS

Several manufacturers make chromogenic chemistry kits. Almost all are designed for use with Kodak Ektachrome 14 paper, the paper now replacing Ektachrome 2203 paper. It has increased color saturation and lower contrast, and therefore has an expanded tonal range. The Kodak Ektaprint R–1000 processing kit can be used with both papers. Other processing kits for use with Ektachrome 14 paper are made by Beseler, Unicolor, and Parcolor. A positive-to-positive printing paper system from Agfa is available in Europe on a limited basis.

THE CIBACHROME SYSTEM

The best known of the silver dye-bleach systems, Cibachrome is sold by Ilford, Inc. In this system, colored azo dyes, rather than colorless color couplers, are

incorporated into the printing paper's emulsion layers during manufacture. The blue-sensitive emulsion layer has a yellow dye, the green-sensitive layer has a magenta dye, and the red-sensitive layer has a cyan dye. Because Cibachrome uses azo dyes, it produces rich, highly saturated colors that are very stable and fade-resistant. The presence of the dyes in the paper also reduces light scatter during exposure, producing a slightly sharper image.

The key part of the Cibachrome process is the dye bleaching step, where the colored dyes are bleached out or destroyed, leaving the proper colors behind. The paper is first developed with a black-and-white–type developer, resulting in a silver negative image. The silver in the negative becomes the catalyst for the chemical bleach. During the bleaching step, the amount of dye bleached away is directly proportional to the amount of negative silver image, producing a positive dye image. The residual silver and other chemical by-products are removed during the fixing and washing steps, leaving a direct positive azo dye image.

The new Cibachrome A–II with matching P–30 chemistry demonstrates one of Ilford's revolutionary developments. Cibachrome A–II is the first self-masking positive print paper. A masking layer has been added to the emulsion, giving the paper a longer tonal range and reduced contrast, especially in the highlight portion of the image. Transparencies that would once have required extensive dodging and burning-in now need little manipulation.

Cibachrome paper has a very wide exposure and color balance latitude. It takes a *large* exposure or filtration change to make a significant alteration in print appearance. The very forgiving nature of this material makes it easier for the beginner. However, to its disadvantage, this latitude often makes it hard to zero in on the final filtration/exposure combination.

Cibachrome A–II papers are now offered in both gloss and pearl surfaces. The new P–30 chemistry is a great improvement over the old, malodorous, and dangerous (especially to plumbing) P–12 chemistry. The P–30 chemistry has a built-in neutralizer to reduce the high acidity of the dye-bleach solutions, eliminating the need for neutralizing tablets or powders as in the older system. Waste solutions are now simply collected in a plastic bucket, allowed to stand, and then discarded.

CHROMOGENIC PRINTING FROM SLIDES

Since the tonal range and the sense of light can change from the original transparency to the final print, a contact sheet will give you some idea of the nature of the change. Exposure variations from slide to slide will also become obvious. But much of this information can be obtained by looking at the slides through a loupe on a light box, so a contact sheet is not absolutely necessary in direct positive printing. Try making a contact sheet using selected images from several rolls of film. This minimizes the number of contact sheets you need to make while maximizing the information they provide.

TEST PRINTS

Color positive printing papers have a very long exposure and filtration latitude, so a test print examining each of these characteristics is extremely important. In the beginning, these tests should be made on two separate pieces of paper. However, once you have a good idea of your normal starting exposure and filter pack, and have some experience behind you, the exposure and filtration tests may be combined into one step, saving paper, chemistry, and time.

Exposure test. Set the enlarger to the

This exposure test was made for 15 seconds with .10Y .05C filtration. The test exposures ranged from f/4 to f/32. Notice the long exposure latitude and relatively small differences created by one-stop variations. Even at the widest aperture, which is three-and-a-half stops off the correct exposure, the image is still easily recognizable. Test prints are sometimes made with half-stop, rather than full-stop, exposure variations. A variation of less than half a stop will not be noticeable. In this print, f/11 seems a bit too light, and f/16 a bit too dark. The best exposure is f/11½.

This filtration test print was made after the exposure was calculated. Each test strip received an exposure of f/11½ for 15 seconds, while variations were made in the filter pack. When you don't have a starting filter pack, use the paper manufacturer's recommended filtration, and vary the filtration by making educated guesses. The starting filter pack for this print was .10Y .15C. This produced a moderate cyan shift; at one variation, .40Y .15C, the scene had a dominant yellow cast. Finally, .25Y .15C was judged to be closest to the original; the final print was made at .25Y .10C.

correct height. It is best to do all test prints at the same magnification as that desired for the finished print. Once the magnification is established, leave the enlarger there. Any alterations in the print size and magnification will require changes in the exposure time as well. Make a five- to eight-stop exposure series for 15 seconds at each aperture, starting at wide-open ($f/2.8$ or $f/4.5$) and stopping down as far as possible ($f/16$ or $f/32$). A full-range exposure test will show the correct exposure along with full information on any dodging and burning-in manipulations that may be needed for the final print. (Information on dodging and burning-in is in chapter 6.) To do a full-range exposure test, move two pieces of cardboard across the printing paper so that they expose only one strip of the paper at a time. (Special test-printing easels that allow you to expose one section of the paper at a time simply by lifting and closing each plastic strip on the easel in sequence are available.) Vary only the aperture, leaving the time constant at 15 seconds. When using an enlarger with low wattage, or when stacking many filters, it may be better to expose for 20 seconds. Set the filtration either to the paper manufacturer's recommendation or to your own standard filter pack. Expose and process normally. The test print will appear darker and slightly bluish when wet, so wait until the print is completely dry before attempting to evaluate the results.

You may find that the best aperture for exposure on the test print is not the one you would prefer to use. In that case, some time and f-stop conversions become necessary. If, for example, the exposure test recommends $f/22$ for 15 seconds, but your lens is sharpest at $f/11$, you must determine the appropriate exposure at that aperture. Since you double the amount of light striking the paper by increasing the aperture one stop, you must compensate by cutting the length of the exposure in half. In this case, $f/22$ at 15 seconds equals $f/16$ at 7½ seconds, or $f/11$ at 3¾ seconds. At $f/11$, 3¾ seconds is a bit short, hindering dodging and burning-in and increasing the chance of error due to timer or voltage instability. The best choice in this case would be $f/16$ for 7½ seconds.

At the other end of the scale, an exposure of $f/2.8$ for 15 seconds requires you to use the enlarger lens at less than its optimum aperture, which could make for a poor print. Converting the time-aperture combination to $f/5.6$ would give an exposure time of 60 seconds. This is a bit extreme, though possible, but compromising at $f/4$ for 30 seconds would be the best choice.

It is important to remember that direct positive prints respond to exposure changes in the same way as slide film does when exposed in the camera. If the print is too dark, increase the exposure; if too light, decrease it.

Filtration test. Using the exposure time and aperture decided by the exposure test, make another series of test strips, this time changing the filtration during each separate exposure. Since the filtration latitude of the paper is very long, it will take increments of 10 percentage points in order to see changes. A change of 20 percentage points in filtration will cause only a moderate change. A large change will require increments of 40 to 60 percentage points of filtration.

In general, start the filtration test using one number as your guide. If you do not have a standard filter pack, use the one provided by the manufacturer on each package of paper. Vary that filtration 10 to 30 percentage points in each direction to find the best combination.

MAKING A FIRST PRINT

The time and printing paper it takes to get from a first print to a final print depends on your experience and evaluation

+ .40B

BLUE

+ .20B

NORMAL

+.40G

GREEN

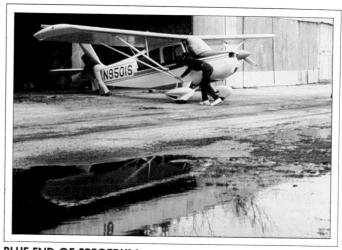

+.20G

BLUE END OF SPECTRUM

The color ringarounds on pages 88 to page 94 demonstrate the effects of specific filtration changes when printing from transparencies. The ringarounds have been divided into the blue and red parts of the spectrum as an aid in discriminating colors. To make these ringarounds, a normal filter pack was altered by adding the filtration shown. If you have a print that matches one of the examples, subtract the amount that was added to cause the shift here. For example, in the +.20B print, additional blue filtration was added to cause the color shift. To remove the bias, subtract .20B by removing .20M .20C from the filter pack. To adjust the color balance in a print made from a positive, subtract the offending color, or add its complement. Use color viewing filters to help assess your filtration. If the print is too blue, say, a yellow viewing filter will help determine the correction. If the print is too green, use a magenta viewing filter to determine the correction; either subtract green (Y + C) or add magenta. If the print is too cyan, use a red viewing filter; either add red or subtract cyan.

+.40C

CYA

+.20C

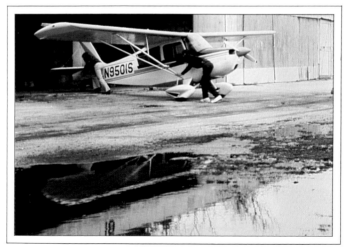

NORMAL

techniques. Using the exposure and filtration information generated by the test prints, make minor adjustments and then make a first print. Make at least one straight print, without dodging or burning-in, to see the complete tonal range of the transparency on the printing paper. Compare the first print to the exposure text to find additional useful exposure information.

ASSESSING FILTRATION

Evaluate the print in bright light, preferably a mixture of tungsten and fluorescent, or daylight and tungsten. Remember that adding a color to the filter pack will increase that color in the print; decreasing it in the pack will decrease it in the print. Generally, a filter pack for a print from positive film contains both yellow and cyan in varying amounts. Magenta is rarely found. Although not common, the filter pack will sometimes contain magenta and cyan only.

Most of the time, the filtration change is obvious. If there is too much yellow, simply subtract some yellow filtration; if too cyan, reduce the cyan filtration. The assessment gets a bit difficult, however, when the color you need to subtract is not part of the filter pack. What should you do, for example, if there is too much magenta in the print but no magenta filter in the filter pack?

Before answering this question, it will be helpful to review the relationship between primary and secondary additive and subtractive colors, since they are important for dealing with the problem. It will also help to review the way filters selectively transmit light. (See the charts on pages 9 and 16.)

The general rule is to subtract filtration whenever possible. If the filter color to be subtracted is not part of the filter pack, then add its complement instead.

Let's relate this to some specific situations. With a filter pack of .10Y .15C, the print mentioned above appears to have a moderate magenta bias. Magenta must be removed from the filter pack, but there is no magenta filter in it. Instead, green may be added to further block magenta transmission. Since green is made up of cyan and yellow in equal amounts, .20C and .20Y filters are added to the filter pack to create a moderate change. The new filter pack becomes .30Y .35C (.10Y + .20Y; .15C + 20C).

If a print has a red bias, remove red from the pack. Since red is composed of magenta and yellow, removing it presents a similar problem, as magenta is not part of the filter pack. Because red cannot be subtracted, its complement, cyan, must be added.

A print with a blue bias can easily have yellow added to the filter pack to correct it. A print with a yellow bias can also easily have yellow subtracted. But what if the print has an extensive yellow cast that would require you to subtract at least .40Y, and the filter pack contains only .10Y? If you subtract .10Y, you must still subtract an additional .30Y. Since there is no yellow left in the filter pack to subtract, add its complement, blue, instead. This is done by combining .30M and .30C filters.

You may find that sometimes you seem to need all three filters in the filter pack. This sets up undesirable neutral density, so one of the filters, usually the least intense one, must be subtracted from the pack, and the same amount of filtration must be subtracted from the remaining filters. Given a pack of .10M .35Y .25C, eliminate the magenta filter, and reduce the intensity of the other filters by the equivalent amount, leaving a pack of .25Y .15C. The chart on page 95 summarizes exposure and filtration changes.

PROCESSING EKTACHROME 14 PAPER

Ektachrome 14 is a fast, resin-coated printing paper for making prints directly

+.40Y

YELLOW

+.20Y

NORMAL

+.40M

MAGENTA

+.20M

RED END OF SPECTRUM
To determine the correction for a print that is too yellow, use a blue color viewing filter; subtract yellow or add blue to the filter pack. A print that is too magenta will be visually corrected by a green filter; subtract magenta or add yellow and cyan to the filter pack. Use a cyan viewing filter to determine the correction for a print that is too red; subtract red or add cyan filtration.

from slides. Because it is very susceptible to the reciprocity effect, its recommended printing speed is 10 seconds or less. Longer exposure will cause the print to shift toward cyan.

Ektachrome papers are designed to be used with Ektaprint R-1000 chemicals. This system produces consistently high-quality prints. The Ektaprint chemistry process is rather involved, requiring five steps plus four rinses. Several independent manufacturers make chemical systems that are compatible with Ektachrome paper but offer fewer steps, greater ease of operation, and less critical temperatures as selling points.

+ .40R

RED

+ .20R

NORMAL

DIRECT POSITIVE EXPOSURE AND FILTRATION CORRECTIONS

Problem	Correction
Print very light overall	Reduce exposure
Print very dark overall	Increase exposure
Part of image too light	Dodge or shade during exposure
Part of image too dark	Burn-in after initial exposure
Print too yellow	Reduce yellow filtration or add magenta + cyan
Print too magenta	Reduce magenta filtration or add cyan + yellow
Print too cyan	Reduce cyan filtration or add magenta + yellow
Print too blue	Reduce magenta and cyan filtration, or add yellow
Print too green	Reduce cyan and yellow filtration, or add magenta
Print too red	Reduce magenta and yellow filtration, or add cyan

BESELER PROCESSING FOR EKTACHROME 14 PAPER

Step	Rapid Drum Processing	Ambient Temperature Drum Processing	Tray in Water Bath Processing
Water presoak	120° for 1 min.	No presoak needed	No presoak needed
Developer	70-75° for 2 mins.	70-75° for 4½ mins.	100° for 1½ mins.
Water rinse	120° for 2 mins.	70-75° for 3 mins.	100° for 2 mins.
	(4 × 30 secs.)	(6 × 30 secs.)	(4 × 30 secs.)
Color developer	70-75° for 2 mins.	70-75° for 5¼ mins.	100° for 2½ mins.
Water rinse	120° for 30 secs.	70-75° for 30 secs.	100° for 30 secs.
Blix	70-75° for 3 mins.	70-75° for 5 mins.	100° for 2½ mins.
Water rinse	Running water at 100° ± 10° for 2 mins.	Running water at 75° ± 10° for 3 mins.	100° for 2 mins.

One of the better paper developers is the Beseler process. Consisting of only three chemical steps (first developer, color developer, blix), and offering a wide temperature processing range, it has simplified the processing of direct positive papers. The processing steps for the Beseler process are summarized in the chart above.

Whichever developing process you choose to use, mix and store the chemicals, and process in trays or drums, as described in chapter 2. Since the chemistry is sensitive to temperature changes, maintain constant temperatures by using a water bath. See the chart on page 96 for a summary of Ektachrome 14 problems and solutions.

PROCESSING CIBACHROME A–II

Cibachrome A–II is a high-quality positive printing paper, producing prints with sharp, fine details, and rich, highly saturated colors. It is a slow paper with a long exposure latitude and relatively low contrast. It will tolerate exposures of up to 60 seconds, although reciprocity failure must be considered. Expose and filter Cibachrome paper as you would any printing paper, and process it in Cibachrome P–30 chemistry. Mix and store all chemical solutions as stated in the kit instructions. The chart on page 102 summarizes the processing steps. Use one ounce of chemistry for each 4 × 5 print, three ounces for each 8 × 10, six ounces for each 11 × 14, and 12 ounces for each 16 × 20 print. Since P–30 chemistry is highly corrosive, it must be neutralized before disposal. Allow the spent chemistry to stand in a plastic discard bucket for the recom-

EKTACHROME 14 POSITIVE PRINTING PAPER PROCESSING PROBLEMS

Problem	Cause	Solution
Very light, washed-out print	Paper loaded into drum incorrectly	Emulsion side of paper must face into drum
High contrast print with magenta stains	Blix contamination of color developer	Discard developer. Follow careful work habits.
Pink streaks or fingerprints	Water on paper prior to processing	Dry drum carefully. Do not handle paper with wet hands.
Light and dark streaks	Insufficient first developer agitation	Use presoak. Make sure processing drum is level.
Bluish-looking black tones	Color developer too dilute, too short, or too cold	Monitor time and temperature carefully
Black spots or specks	Dut on slide	Clean slide carefully
Overall muddy appearance	Dilute, exhausted, or old blix	Use fresh chemistry
Uniform deep blue/cyan stain	Paper fogged by exposure to light	Handle paper in total darkness. Store paper in lightight place.

PROCESSING CIBACHROME A-II PRINTS

Step	Time	Temperature	Agitation	Comments
Water presoak	1 min.	75°	Continuous	Needed only for 16 × 20 print
Developer	2 mins.	75° ± 3°	Rapid for first 15 secs., continuous and gentle for rest of cycle	Start draining developer into waste bucket (*not* sink) 10 secs. before end of cycle
Water rinse	15 secs.	75° ± 3°	None	Fill and drain twice
Bleach	4 mins.	75° ± 3°	Rapid for first 15 secs., continuous and gentle for rest of cycle	Start draining bleach into waste bucket 10 secs. before end of cycle
Water rinse	10-15 secs.	75°	—	Rinse only if there is an unpleasant odor
Fixer	3 mins.	75° ± 3°	Continuous and gentle	Drain into waste bucket for 5-10 secs. after cycle ends
Wash	3 mins.	75° ± 3°	Rapidly running water	Wash in tray

CIBACHROME PROCESSING PROBLEMS

Problem	Cause	Solution
Dark, flat print	Developing time too short	Monitor time and temperature carefully
Light print with density loss	Developing time too long	Monitor time and temperature carefully
Image dark red and reversed	Partial or complete exposure through the back of the print material	Identify emulsion side of paper
Fogged and dull print	Incorrectly mixed bleach solution, or insufficient bleaching due to cold chemistry or too little time in chemistry	Mix new bleach solution. Follow processing instructions closely.
Dull print with dirty stripes	Drum not washed properly before use	Follow good darkroom habits
Dark print with dull tones	Bleach and fixing bath used in reverse order	Follow processing instructions closely
Flat, yellow print	Fixing bath omitted	Follow processing instructions closely

RECIPROCITY FOR CIBACHROME A-II

Initial Exposure Time	Use this Time to Double Exposure
10 secs.	21 secs.
15 secs.	35 secs.
20 secs.	48 secs.
30 secs.	78 secs.
40 secs.	112 secs.
50 secs.	150 secs.

mended length of time, and then dispose of it normally.

When using an enlarger with a low light intensity, when making a great magnification, or when stacking a large number of filters, you may need a long exposure time, along with a wide-open aperture. Use the chart above to adjust exposure times to compensate for reciprocity failure. The effect of reciprocity failure may also cause the print to shift to the blue-cyan part of the spectrum.

Add yellow, and subtract cyan filtration in increments of .20 to compensate for reciprocity and rebalance the colors correctly.

Occasionally indentification of the emulsion side of the printing paper is difficult, since both sides are smooth and the paper must be handled in total darkness. The emulsion side is very slightly smoother; with practice, the difference is discernible. To avoid the problem, always place the paper package emulsion-side up when preparing to print. The black inner pouch has a label that identifies the emulsion side of the paper.

Drum processing is recommended for Cibachrome papers, since the procedure requires total darkness for the first five minutes of processing. The chart on this page summarizes problems and solutions for Cibachrome A-II papers. As in all processing systems, consistency is its own reward.

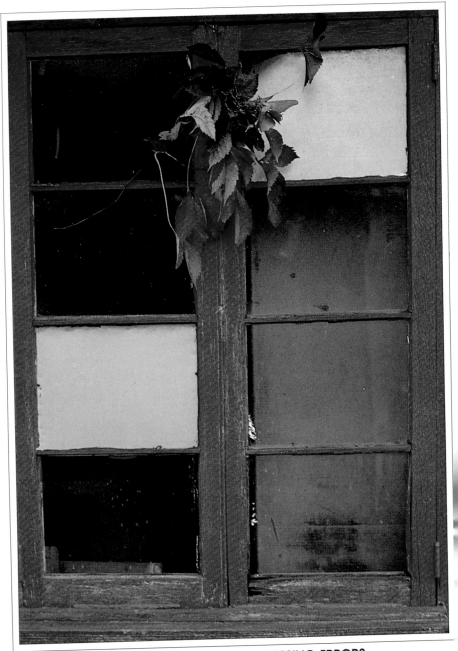

POSITIVE-TO-POSITIVE PROCESSING ERRORS
The photographs on pages 98 to 103 show common positive-to-positive processing errors.

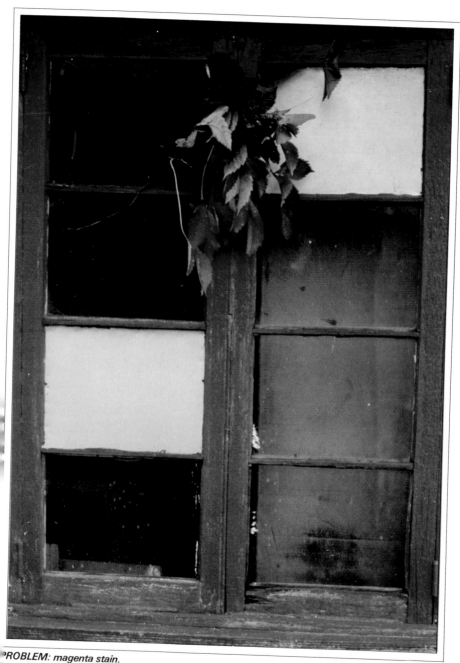

PROBLEM: magenta stain.
CAUSE: contamination of color developer with bleach-fix

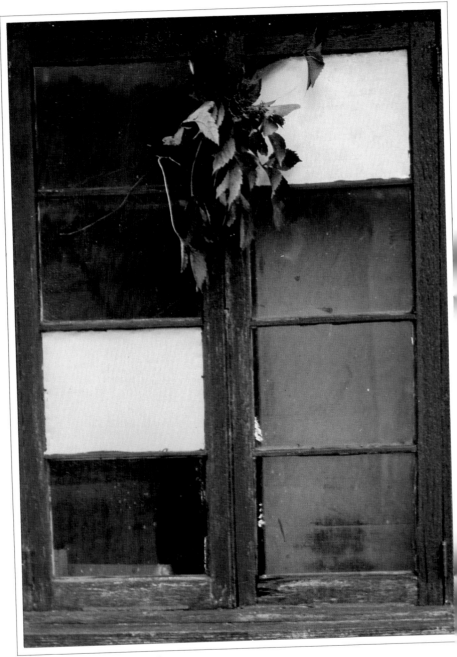

PROBLEM: black-and-white print.
CAUSE: contamination of color developer with stop bath.

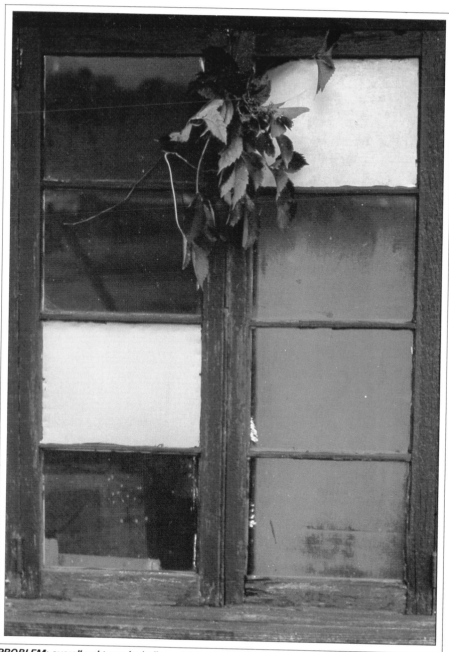

PROBLEM: overall red tone, including print borders, with partial or complete reversal of tones.
CAUSE: image struck by light during first development.

PROBLEM: light, washed-out image.
CAUSE: paper loaded incorrectly into processing drum, with emulsion facing wall of drum.

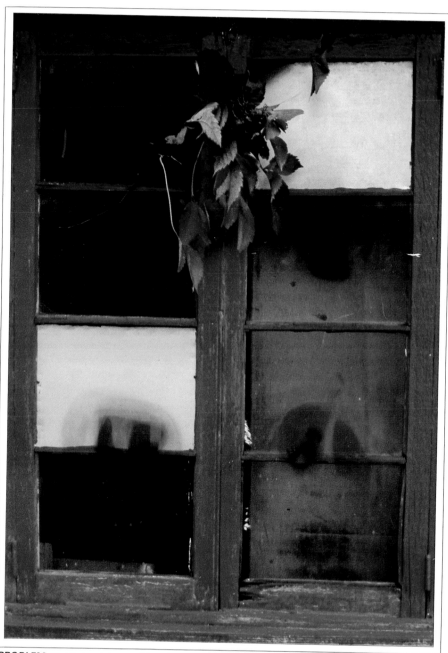

PROBLEM: *magenta stain, muddy colors.*
CAUSE: *bleach-fix contamination of first developer.*

5

Diffusion Transfer Systems

FOUR NEW COLOR PROCESSING SYSTEMS HAVE recently been introduced. All are based on a well-known but little-used system of processing—diffusion transfer. All the systems—Ektaflex from Kodak, Agfachrome Speed from Agfa, and Polacolor and Polachrome from Polaroid—are based on the same idea. The image is exposed onto a film base (either in an enlarger or in the camera), developed using an activator solution, and then transferred or laminated onto a piece of receiver paper. Although there are major differences in the chemical technology of each system, the processing concept is the same.

THE KODAK EKTAFLEX SYSTEM

One of the most difficult aspects of the color printing is controlling all the variables: mixing the chemistry, monitoring time and temperature, and avoiding contamination in the sequence of processing steps. In 1980, Kodak changed that with the introduction of a single-solution, one-step, instant color-printing system. Although the process is slightly more costly than standard processing, to many photographers the convenience justifies the expense.

System operation. Like conventional color printing papers, a sheet of Ektaflex film has cyan, yellow, and magenta image-forming layers on a base support. The film is exposed normally in the enlarger, and then inserted into the Ektaflex printmaker, where it is processed in the activator solution for 20 seconds. It is then laminated in the printmaker onto Ektaflex PCT paper. During the six-to fifteen-minute lamination period, the released dyes migrate (diffuse) onto the paper. The PCT film is then separated from the PCT paper, and the process is complete. The print requires no washing or stabilization treatment; simple air drying is all that is necessary.

Ektaflex materials. In addition to a conventional color enlarger (or black-and-white enlarger with color filters), Ektaflex printing requires the following materials:
• Kodak Ektaflex printmaker model 8, or the motorized version made by Durst.
• Ektaflex PCT film for negatives or PCT film for positives.
• Ektaflex gloss- or flat-surface PCT paper, used for both negatives and positives.
• Ektaflex PCT activator solution (this comes premixed).

PCT paper does not need to be refrigerated. However, the film for both positives and negatives should be stored below 55°F, and must be allowed to warm up to room temperature two hours before use to prevent condensation. Film and paper are available in 10-, 25-, and 100-sheet packages, in 5×7 and 8×10 sizes. The PCT activator solution comes in half-gallon containers. Be careful when pouring it into the printmaker, since it is extremely caustic. One container of activator will process 75 8×10 prints; when exhausted it will turn a medium pink color.

EKTAFLEX STEP-BY-STEP

With Ektaflex as with all printing systems, read and follow the manufacturer's instructions carefully. Using the printmaker is not difficult. Set up the machine as directed in the manual, and practice using it in room light before making a print. The processing steps are explained below.

The parts of a Kodak Ektaflex printmaker, model 8, are shown here. The printmaker is open. (1) Paper shelf; (2) ramp; (3) ramp slide; (4) crank; (5) film rake handle.

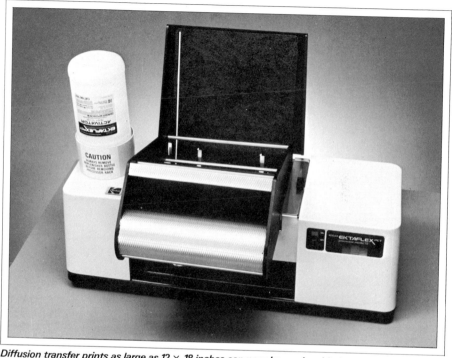

Diffusion transfer prints as large as 12 × 18 inches can now be made with the new Kodak Ektaflex PCT processor, model 12.

1. Fill the printmaker tray with the activator solution, up to the indicated mark on the fill post. Avoid spills and splashback by pouring slowly and carefully. Do not get the solution on your skin; wash immediately in water if you do. Make sure the drain-tube valve is closed; otherwise, the activator solution will spill out.

2. Close the machine, and carefully dry all parts with a towel. Small drops of solution on the machine can cause processing errors.

3. Load a sheet of PCT paper into the paper shelf of the printmaker, *emulsion-side* (white-side) *down*. Since the receiver paper is not light sensitive, avoid errors by loading the paper in room light. Make sure the paper has gone all the way under the teeth of the paper rake, is not on an angle, and is pushed firmly up against the rear wall of the paper shelf.

4. Insert a clean negative or transparency into the negative carrier *emulsion-side up*. When projected onto the easel, the image will appear backward. When the image is transferred from the film to the paper, it will reverse to its correct orientation.

5. Turn off the room lights, and load the film into the easel, *emulsion-side up*. Feel for the film notches (one for negatives, two for positives) as a guide. The notches should be in the upper right-hand corner of the film as it faces you. If you accidently place the film emulsion-side down, simply turn it over and reexpose it. The base is opaque, so light will not reach the emulsion side.

6. Adjust the filtration, *f*-stop, and timer, and make a test print as described in chapter 2. The suggested filter pack

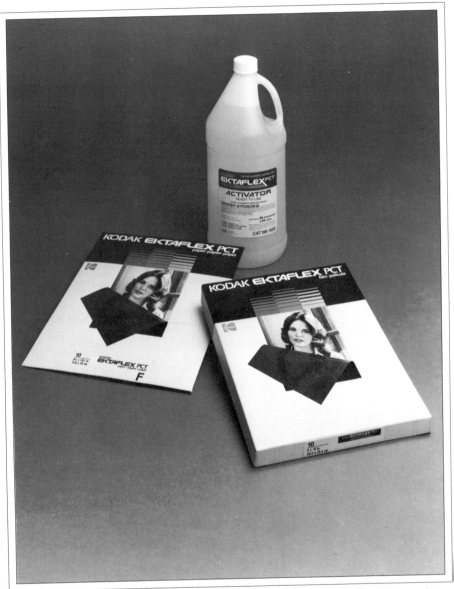

Ektaflex PCT film and paper come in 10-, 25-, and 100-sheet packages, depending on paper size. Ektaflex PCT activator comes in three-quart containers.

for printing from negatives is .50Y .60M at $f/8$ or $f/11$ for 10 seconds. For positives, the suggested pack is .10Y .10M at $f/8$ or $f/11$ for 15 seconds. The suggested packs are generally quite accurate, particularly for negatives.

7. Handling the film by the edges only, transfer the exposed film from the easel to the film-loading ramp of the printmaker, *emulsion-side up.* Again, the notches on the film should be in the upper right corner, when facing you, and in the upper right corner of the ramp. Make sure the film edges are under the film-loading ramp edge, using the luminous dots on the printmaker as a guide. When the film is correctly loaded, the four luminous dots should be visible. If the film is incorrectly loaded, it will buckle and pop out of its track when pushed down the ramp.

8. Start the timer and smoothly push the film slide down the ramp until it stops. Fast or jerky motions may cause the activator solution to splash out. If so, dry the printmaker before attempting another print. Make sure to return the film-advance slide to its locking position or it will interfere with the film-advance rake.

9. The film soaks in the activator solution for a total of 20 seconds. After 15 seconds, begin turning the hand crank clockwise at a moderately fast speed (about two revolutions a second) in preparation for lamination. At 20 seconds, push the film-advance rake handle toward the rollers with your left hand, while cranking the rollers with your right. During this step, the film is laminated to the paper, forming a light-tight sandwich. The room lights may now be turned on.

10. Set the timer to 10 minutes for negatives or 15 minutes for transparencies. Lay the film sandwich flat and leave it alone for the entire timing sequence. At the end of the time, peel apart the film from the paper. The print

is finished. Discard the film carefully, since it contains caustic chemicals.

PROCESSING ERRORS

Basically, filtration and exposure problems with Ektaflex are the same as in all other color printing systems. The most common Ektaflex error is partial lamination of the film and paper, usually due to incorrect positioning of either the film or the paper in the printmaker. Consult the chart on page 114 for common errors and appropriate corrective actions. Organized work habits are an important part of success with the Ektaflex system. Be sure to drain the activator solution from the printmaker at the end of the printing session, and flush the printmaker with warm water, making sure the rollers are clean.

EXPERIMENTING WITH EKTAFLEX

The color, tonality, and density of an Ektaflex print can be manipulated in several ways. Changes in the lamination time, relaminating the film onto a second piece of paper, exposing the film to light and then relaminating it, printing transparencies on negative film, printing negatives on positive film and printing black-and-white negatives onto color paper using various color filters are some of the methods that will produce a variety of creative or even bizarre results.

Save your partially exhausted activator solution, and use it for lamination alterations and other manipulations. When working with manipulations, the activator solution may become contaminated and need to be discarded.

LAMINATION MANIPULATIONS

Varying the lamination time. Shortening the lamination time limits the amount of dye that will transfer onto the receiver paper. Almost all the dye has migrated after five minutes, so any manipulations after that time will be very subtle, and

Here the film was laminated onto the wrong side of the transfer paper.

Nonlamination of the film and paper is caused by water or chemistry droplets on the paper.

The film and paper were separated during development, leading to improper lamination. The circular separation marks are caused by dirt or air bubbles on the paper.

If the paper is not placed under the rake, the misalignment causes improper lamination.

mostly demonstrate a slight increase in print density and color saturation. Lamination times under five minutes will result in pale, washed-out prints, with a faded, high-key quality.

Multiple laminations. Another way to vary the print density as well as the color balance is multiple laminations. Expose and laminate a print in the normal manner. Since the film remains sensitive to light, separate the sandwich in total darkness and relaminate the film onto another piece of paper. Do not let the film soak in the activator solution for more than four to five seconds, or the film emulsion will become too soft and the dyes may contaminate the activator. The length of time the first print is laminated will affect the density, saturation, and color balance of the second print. A one-minute lamination time for the first print will produce a second print that is

well-saturated and rich. A five- to ten-minute lamination time for the first print will produce a second print that is pale and faded. All second prints should be laminated for their normal time.

Solarization. To solarize an Ektaflex print, expose and print in the normal manner. Separate the sandwich after one minute, briefly expose the film to light, and then relaminate it onto a fresh sheet of receiver paper, allowing them to stay together for the normal time. Massive reexposure of color negative film will produce a bright magenta-red print, with shadow areas that have reversed their tones and become lighter. Exposing transparency film to room light and then relaminating it will produce a print with bright yellow highlights. Controlled reexposure with a low-wattage lamp, safelight, or electronic flash will produce additional variations. Relaminating three

The Newton's rings at bottom left (under the jumper's arm) were formed by using a glass negative carrier.

Handling the film/paper sandwich too soon after processing causes delamination of the film and paper at the edges. Place the film/paper sandwich flat after it leaves the processor. Do not touch or bend it until the development time has ended.

KODAK EKTAFLEX PROCESSING ERRORS AND SOLUTIONS

Error	Cause	Solution
Partial lamination of film to paper	Paper not pushed completely under paper rake, and advanced ahead of film into rollers	Check position of paper in room light before printing
Image crooked on paper	Paper placed on an angle in printmaker	Position paper against rear wall of paper shelf
White or light corner of print	Edge of paper separated during lamination time	Avoid handling sandwich, especially at corners
White or light patches all over print	Film and paper did not laminate smoothly	Paper or film kinked or bent; store materials correctly
Circular dark spots in image area	Warm fingers left marks during beginning of lamination	Handle sandwich by edges only
Fine lines on image	Film inserted into activator solution unevenly	Practice pushing film-loading slide smoothly
Darker or lighter areas across entire print	Skip marks during lamination; uneven cranking	Clean rollers and check gears; crank at constant speed
Film does not slide down ramp smoothly	Film loaded incorrectly; film-loading ramp wet; film-advance handle not lined up with mark	Check film loading; always dry ramp if activator splashes out; check handle position
Black edges on print wider than 1/8 inch	Film emulsion stuck to paper — activator or lamination time too long	Soak in activator 18–20 secs.

or four times will alter the image still further, especially if the film is further exposed to light and solarized. The options available are numerous, and trial and error is the only way to discover what will work.

SWITCHING FILMS

Another way to alter the color balance and density of a print is to switch the negative and positive films. Make a print from a slide using negative film; expose and laminate normally. The tonalities will reverse: blue skies will become yellow, and shadow areas will become highlights. Reexposure to light and a second lamination will alter the tones again, creating a partial or full reversal of highlight and shadow areas, but with strange tonalities. Printing with a negative onto reversal film will also cause the colors and highlight and shadow areas to shift. However, the final print will be very low in contrast and flat in tonality. Again, experimentation is the only way to find what works.

AGFACHROME SPEED

Agfa-Gevaert has recently introduced a diffusion transfer color-printing system

CREATIVE EKTAFLEX MANIPULATIONS

Printing a transparency onto negative film causes a reversal of tones—magenta becomes green, blue changes to yellow—as shown here and on page 116. Highlights and shadows reverse—light areas become dark, dark areas reverse to white. The cyan cast in the white airplanes takes on a reddish-black cast.

It can be used for making color prints from transparency film, either with an enlarger or in the camera. Processing is even less complex than the Ektaflex system, requiring soaking the print paper in an activator solution for 90 seconds using conventional trays, tanks, or drums. Since Agfachrome Speed is a single-sheet, self-contained system, rather than a two-piece, pull-apart system, it does not require a processing unit for lamination. The color transparency is placed in the enlarger, emulsion-side up. The print material is placed in the printing easel, emulsion-side down, in total darkness, and exposed with a yellow and cyan filter pack for 10 to 15 seconds.

Like all positive printing systems, the exposure side of Agfachrome Speed paper is black, while the picture side is white. Since the material is not notched, it is a bit difficult to tell the sides apart in the dark. Practice feeling the paper. The black side feels smoother and a bit slippery; the white side feels rough in comparison. If the print side is accidentally exposed, it can be turned over and reexposed properly. The print side is opaque, and light will not travel through it. The material has a very wide exposure latitude, which makes for a good first print, but it is a bit hard to make subtle corrections. Exposure changes are made in one- and two-stop increments. Filter pack changes are made in increments of .20 to .30 for minor changes, and .40 to .60 for moderate corrections.

Agfachrome Speed material has an additional new aspect. By varying the activator solution, the contrast of the print can be controlled. Diluting the activator solution will produce a high-contrast print; however, this weaker solution will require additional exposure in the enlarger. Contrast can be decreased by adding two to eight grams of potassium bromide per liter to the solution. This may create the need for additional yellow filtration changes, as the film has a

tendency to shift to blue. It is possible to print with a two-bath solution, one hard and one soft, as is done in fine black-and-white printing. This allows full control over the shadow and highlight portions of the image.

Agfachrome Speed is also an effective in-camera material for working in tungsten illumination. Agfa has rated the material at ASA/ISO 16. By processing it in a high-contrast activator solution, the ASA/ISO can be raised to 32. It's a little slow for portraits, but excellent for still-life subjects.

Agfachrome Speed has its flaws, although the materials should improve over the next few years. One of the larger drawbacks is the softening of the image during the transfer process. Ektaflex has had this problem also, but Agfachrome Speed material is noticeably unsharp. Another drawback is that there are chemical residues left in the print, even after the recommended washing time, that will cause the print to deteriorate in time.

POLAROID INSTANT FILM SYSTEM

Polaroid is well-known as the leader in the instant color-print field, but the general public is aware of only a few Polaroid films. The company also produces a number of color films for professional and scientific applications. Polacolor 2 film for professional applications utilizes diffusion transfer to produce an instant color print in $3\frac{1}{4} \times 4\frac{1}{4}$, 4×5, and 8×10 sizes. Each individual film packet contains a color negative, a positive image-receiving sheet, and a pod containing the processing reagent. After exposure, the negative is placed face-to-face with a positive image-receiving sheet. This sandwich is drawn between a pair of steel rollers in the camera or camera back. These break the pod containing the activator solution. The processing reagent is spread evenly between the positive and negative, activating the dye developers.

Polacolor Type 808 print film is an 8 × 10 film that requires a separate negative and positive sheet. Due to its size, laminating is done by a processing unit with large steel rollers to break the pod and evenly distribute the processing reagent. Originally made to be used in a camera, the film immediately found its way into the professional darkroom. As a result, two films are now made to be used in the enlarger: Polacolor 809, which produces a brilliant color print in 60 seconds, and type 891, which produces color transparencies for overhead projection. The 891 system is similar in concept (though not in technology) to Kodak Ektaflex. A color slide is placed in the negative carrier — emulsion-side up — and projection-printed onto a piece of film. The film is processed by an activator solution, and laminated onto a piece of receiver paper using a separate processing unit.

Polaroid has recently introduced an instant 35mm color film, Autoprocess 35, that produces a color transparency, ready for viewing, in under five minutes. The system consists of the Polachrome 35mm film (in 12- or 36-exposure rolls), the Autoprocessor, the Autoprocess slide mounter (optional), and 35mm slide mounts. The chemical reagent is included with each film pack. The film is balanced for daylight or electronic flash, and is exposed at ASA/ISO 40. After exposure, the rewound film cassette and processing pack are inserted into the Autoprocessor. The processing pack contains a strip sheet, the processing fluid, and an applicator that spreads the fluid evenly. The film is pulled through the Autoprocessor, and is laminated onto the strip sheet. After one minute of processing time, the strip sheet is peeled away, leaving a positive image on a clear polyester support.

Polaroid professional films are not always readily available, but they can easily be ordered from a dealer.

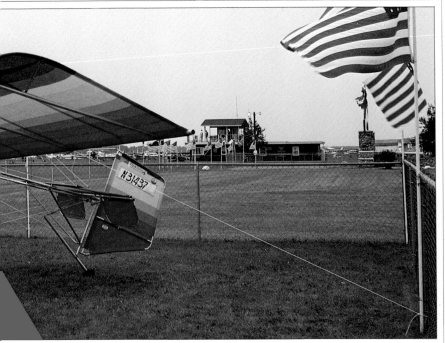

In another variation of printing a transparency onto negative film, the grass reversed to its complementary color, red, and the white sky became black (normal, bottom; reversal, top).

Unreal images can be created by printing a transparency onto negative film. Since this technique increases contrast, start with slides that are relatively low in contrast.

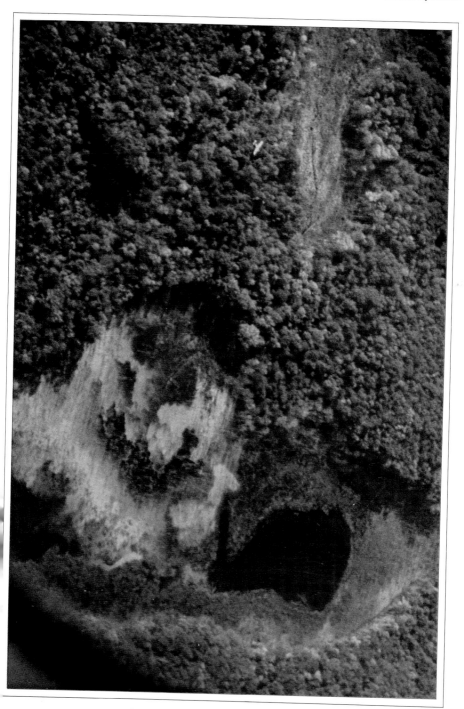

6

Fine Color Printing

THE TECHNIQUES OF PRINT MANIPULATION are valuable not only for correcting problems but also for their ability to strengthen a statement and complete a visual idea. Basic manipulation techniques allow you to control and modify the density, tonality, color, and contrast of portions of the image.

CROPPING

The simplest technique for isolating or strengthening a portion of the image is cropping. Preliminary cropping information can be determined from the contact. Cut a rectangular hole slightly smaller than a contact-size image in a piece of cardboard, and use it to separate a contact image from the rest of the sheet and visualize different croppings.

One way to crop a full-size print is to raise the head of the enlarger. This magnifies the portion of the image you want to print, while eliminating the portions you don't. However, magnification will also enlarge all flaws, including the grain structure, and is not always appropriate. If a negative or positive will not hold up to cropping by enlargement, isolate parts of the image by bringing in the blades of the enlarging easel. This reduces the overall size of the image without bringing out its poorer qualities.

CONTROLLING PRINT DENSITY

The ability to make local changes in tones within a print is a basic reason for doing your own printing. Print density can be controlled in two ways: dodging and burning-in.

Subtracting or withholding light from a specific area of a print is called dodging. To dodge, a tool is held in front of the enlarger lens, blocking the light for part of the exposure. The tool is continuously moved to blend the lightened area in with the rest of the print. Adding light to specific areas of the photograph is called burning-in. The usual tool for this is a piece of cardboard with a hold cut in the center. The cardboard is held beneath the enlarger lens and the hole is used to direct additional light onto the paper after the normal exposure time.

Whether you should dodge or burn-in depends in part on what sort of print you are making. When printing from a negative, dodge to lighten and burn-in to darken. When printing from a transparency, do just the opposite – burn-in to lighten, and dodge to darken. Remember, dodging and burning-in are best used to heighten and improve – not to rescue.

DODGING

Tools. A simple dodging tool can be made by attaching a cardboard disk to a piece of stiff wire six to eight inches long, using black photo tape. Different sizes and shapes of cardboard dodgers can be used for a variety of purposes. Circular shapes are good for faces; rectangles are handy for skies and buildings. Tools with interchangeable parts can also be purchased.

Technique. To determine the correct dodging time, consult your test print. During the initial exposure insert the dodging tool in front of the enlarger lens, directly over the appropriate portion of the image. Move the tool continuously during the exposure, and time the duration of dodging. Keep a record of manipulation times on your data sheet. Think carefully about where you will insert the dodging tool. Since the wire will

Pictures are cropped to remove distracting details, to strengthen the center of interest, and, in extreme cases, to create a center of interest. These three photos show how minor cropping can strengthen an image. In the original photograph (above), taken with a 4 × 5 camera, there was too much detail. The shot was cropped at the top (opposite top). To strengthen the group structure, the final print (opposite bottom) was cropped even further at the top.

also cause some dodging, look for areas of the print that will be the least affected by its presence. Overdodging, especially in a shadow area, is very obvious; the goal is subtlety.

BURNING-IN

Tools. The basic burning-in tool is a piece of cardboard, preferably black on one side and white on the other, with a hole cut in the center. (The black side faces down to avoid reflecting light onto the print.) The size and shape of the hole depends on the need: a hole with a one-inch diameter is good for faces, but you'll need something smaller for eyes, for example. Cardboard that is too thin will transmit light, so be sure to use something fairly thick and opaque. A simple and flexible burning-in tool can be made by cutting a piece of cardboard into two L shapes. Overlap the two to

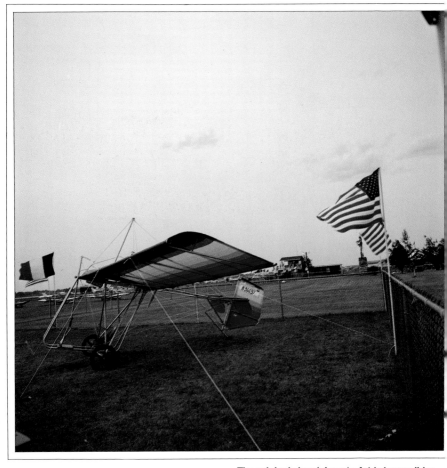

The original shot (above) of this hang glider was taken using a 70mm Hasselblad. To strengthen the geometric relationships of the shot, it was cropped down to the proportions of a 35mm frame (right). Massive cropping of this sort can be done only with a very sharp, grainless negative — one with no flaws.

get variations in the size and shape of the burned-in area of the final photograph.

Techniques. Determine the burning-in time needed from the test print. After the main exposure is made, the additional exposure is added to specific portions of the print. Keep track of the duration of burning-in, and record the information on your data sheet. Move the card continuously during the exposure to blend all the tones and to avoid leaving discernible edges. One of the trickier aspects of burning-in is finding the spot to be manipulated. This is especially hard to do when the area is small, a lot of filtration is being used, and the lens is

topped all the way down. A good way to make the procedure easier is to use two L-shaped cardboards (or any other tool) of the desired shape and size for the area to be manipulated and a white cardboard about 8 × 10 inches. After the initial exposure, place the cardboard over the printing paper and turn the enlarger timer to focus or to the on position. The image is now projected onto the white cardboard, and you have time to find the problem area. Hold the burning-in tool directly over the spot, and remove the cardboard. After burning-in the area, block the light once again with cardboard, and find the next area to be manipulated. This technique works particularly well for a print that needs a great deal of work.

CONTROLLING COLOR

Adding color, correcting color, and shifting color in a specific area of a print are techniques that can be used to modify and improve an image. The basic filter pack that is appropriate for the overall photograph may be altered for particular areas of the image. This selective filtration is done with color compensating (CC) filters, used either during or after the main exposure. Color compensating filters are high-quality gelatin filters, made specifically for this purpose. Only CC filters should be placed in front of the lens. Do not use color printing filters, or acetate filters, or filters that are dirty or have scratches or fingermarks.

COLOR CORRECTION THROUGH FILTRATION

	Too Yellow	Too Magenta	Too Cyan	Too Blue	Too Green	Too Red
Negatives	+ Y or − B	+ M or − G	+ C or − R	+ B or − Y	+ G or − M	+ R or − C
Positives	− Y or + B	− M or + G	− C or + R	− B or + Y	− G or + M	− R or + C

In this exposure test for a print from a transparency, the best exposure for the main area of the print is seen to be f/5.6 for 20 seconds. The best exposure for the sky, however, seems to be f/2. To get the best print, it was decided to withhold light, or dodge, the sky area during the exposure.

The first print of the scene shown in the test print above top was made at f/5.6 for 20 seconds. The sky is pale and empty, even though the original slide has a strong cloud structure.

To darken the sky and bring out the clouds, this print was dodged for half the exposure time, or ten seconds.

In this print, the sky was dodged for an additional four seconds (14 seconds in all) for a dramatic result.

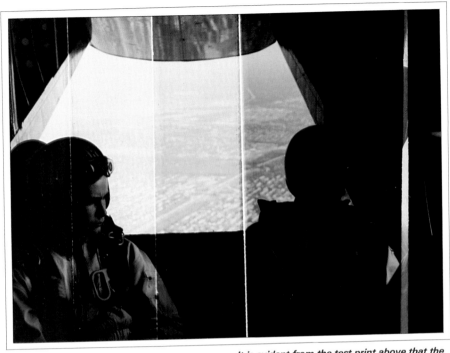

It is evident from the test print above that the exposure time for the jumpers differs from that for the background. The best exposure for the jumper near the window and for the overall shot is f/32. The jumper on the left side of the print, however, needs one-third less exposure to retain detail. To get detail in the city that is the background, two additional stops of exposure time are needed. When confronted with multiple manipulations, it is best to make a master sketch (above right). Review the sketch before printing to help organize the manipulation sequence. The final print (bottom right) was made at f/32 for 10 seconds, with manipulations following the sketch.

Technique. The techniques of controlling color vary, depending on whether you are working with positives or negatives. The chart on page 127 will help keep things straight. When printing from negatives, you can darken and intensify an area by placing the appropriate CC filter over the opening in your burning-in tool and burning-in the area for an additional time. For larger areas such as skies, use the filter itself in front of the lens. Use a piece of cardboard to block the light from the areas you don't want to affect. Another way of changing the color balance of an area is to subtract color. To do this, dodge the area with the appropriate neutralizing filter (red subtracts green, for example), during the initial exposure. You may then burn-in a more appropriate color.

When working with positive materials, do the opposite. To darken and to saturate the color of a particular area,

Some slides and negatives are especially difficult to print, requiring multiple manipulations and a careful battle plan to achieve a high-quality print. In the pictures shown here, the low-level illumination of the original shot caused tricky printing problems when trying to show both highlight detail and the sun disk. In the print directly above, printed at f/5.6 for 20 seconds as the main exposure, the sky is blank. Two attempts at darkening the sky by dodging were total failures (above top). The battle plan was then reversed (top right). The sky became the main exposure, at f/16 for 20 seconds; the plane was burned-in for 20 seconds at f/8 (two additional f-stops), and the ground was burned-in for an additional 20 seconds at f/8 (three additional f-stops). An earlier attempt at dodging the sky with a .40 cyan filter (a common approach to darken skies) produced no appreciable results. The print at bottom right shows a heavy-handed, obvious dodging technique. This type of negative is sometimes best printed using the highlight mask technique (see chapter 7).

dodge the area during the main exposure, using a CC filter of the same color you wish to add, held below the lens and moved continuously during the exposure time. To correct a color cast, or to lighten an area, burn-in with the appropriate filter placed over the opening in the burning-in tool.

CONTROLLING CONTRAST

The human eye can perceive a highlight-to-shadow brightness range of about 1,000:1. Normally processed black-and-white films can capture a brightness range of 8:1; when manipulated by development, the range can be extended to 32:1. Color films are much less tolerant of extremes in lighting situations. Color negatives have a brightness range of 8:1; transparencies have only a 3:1 ratio.

Since most color printing papers are higher in contrast, the brightness range of a subject may be too wide to reproduce well on them. The corrective process for controlling color materials is called masking, and involves making either a shadow or highlight mask, using black-and-white film. Masking is a fairly complex process, but it can save a print, and can also be used for unusual manipulative effects. A complete explanation of the process is in chapter 7.

A simple technique called flashing can be used for general, overall contrast control and for reducing color casts. It is not as effective as masking, especially in the shadow areas, and it can also create a color bias that may require additional compensation. To flash, first make a normal exposure, and then remove the negative or slide from the carrier. If you wish only to reduce overall contrast, remove all filtration; if you wish to modify a color cast, alter the filtration as appropriate. Next, expose the printing paper for a very short time: $f/16$ for one or one-half second. This gives the paper an overall tonality that can slightly reduce the brightness of the highlights.

The magenta color of the sky in the photograph on page 129 seemed too warm. To correct the color and create a traditional blue sky without disturbing the overall warm tonality of the main image, the sky area of this print was dodged for ten seconds with a blue filter in front of the enlarger lens.

Here, the print was dodged with a blue filter for ten seconds, and was also dodged for ten seconds without the filter during the main exposure.

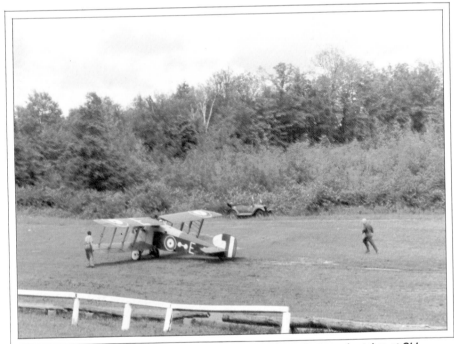

There is often no one absolute color for a photograph. In these photographs, taken at Old Rhinebeck in New York State, each version seems "correct" and appears to represent a different time of day or year. Which color is the right color? The answer is whichever you prefer.

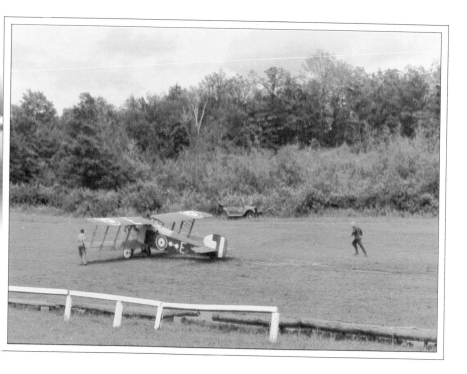

7

Color Manipulations

ARKROOM MANIPULATIONS ALLOW THE DIS-
ortion of reality and the creation of im-
ginative, unreal, often magical images.
he basic manipulation techniques are
andwiching, combination printing, so-
arization, masking, and posterization.

Sandwiching and combination print-
ng involve the use of two or more nega-
ves or positives to create a new image.
hese techniques can be used simply, say
o add clouds to an empty sky, or dra-
natically, to suggest a scene not found
n reality. To join images without an ob-
ious seam requires a bit of planning
nd some practice. Sandwiching, the
asier technique, may require several
ours of work to make a good print;
ombination printing allows more final
ontrol, but may take even longer.

Solarization is the full or partial rever-
al of tones in an image, caused by light
triking the paper or film during the de-
relopment process.

Masking and posterization are com-
olex, multistep techniques. Both pro-
cedures use high-contrast graphic arts
ilm, as well as a film registration system
o line up the images correctly on the
orinting paper. Each technique has
several steps, but they are based on
darkroom information you already
have. They are not difficult. They are
time-consuming, however, and you must
allow for this when making a high-qual-
ity photograph.

SANDWICHING

A sandwich print is made by enlarging
two pieces of film that are in direct con-
tact with each other. Follow the steps
outlined below.

1. Using a light box, combine two
negatives or positives. Arrange the film

so that the image makes visual sense.
Transparencies are easier to visualize in
combination, but not always the easiest
to print. Sandwiching two transparen-
cies can create excessive contrast build-
up, so choose slides that are relatively
low in contrast. Negatives have less of a
contrast problem, but choose two nega-
tives that are similar in contrast and den-
sity to minimize dodging and burning-
in. Negatives and transparencies can
also be combined for a real-unreal
effect.

2. Tape the two pieces of film to-
gether, using thin pieces of black photo
tape, or hold them in place with a glass
carrier. Make sure the film is clean.

3. Make an exposure test print at $f/8$,
$f/11$, $f/16$, and $f/22$. Because you are
exposing through two layers of film, ex-
posure times will be long — from 20 to
50 seconds. Work at the smallest aper-
ture possible to maximize sharpness and
depth of field. Since the exposure times
tend to be long, negatives that are a bit
thin and flat will be easier to print.
Dense negatives require a longer expo-
sure time and will suffer from contrast
problems.

4. Look at the test print for exposure
information for both images. Evaluate
for dodging and burning-in informa-
tion, overall color filtration, and local
color correction.

5. Print and process normally. Deal
with small problems like dust and mis-
alignment as they come up. Try another
sandwich combination if your original
choice isn't working.

COMBINATION PRINTING

When two negatives or slides are ex-
posed separately onto the same piece of

The print at bottom is a straight print. The print at top was solarized by exposing it to light briefly during processing.

paper in the enlarger, there is much more control over the final image. Combination printing is a bit tricky. It involves some preparation, and there are two main areas of difficulty: correct registration of the film, and placing the image using masks. In the discussion below, it will be assumed that negatives are being used, although slides work almost as well.

Registration. Correct registration of the negatives is crucial to the success of a combination print. This can be achieved in several ways. Negatives may be positioned or aligned at the negative stage of the enlarger by taping them to the carrier. Use the tape to form a hinge, swinging the negatives in and out as needed. Alternatively, place them in the negative carrier one at a time, and reposition the image each time. In this case, it is much easier to use two or more carriers. Larger negatives can be registered at the printing stage of the enlarger, using a pin registration system (see page 156). Another method is to split the negatives, placing one in the carrier and an enlarged negative at the print stage. You could also use two or more enlargers. Position the image using a diagram as a guide, and move the paper from easel to easel.

Placement of image using masks. To make a good combination print, you will need to make masks and dodgers for each different print. These will be used to block light during the separate exposure times. A mask is easily made by projecting each image onto separate pieces of lightweight cardboard and cutting appropriate openings. During printing the masks can be held in a jig several inches above the print, or moved during the exposure, like a large dodging tool. Conventional dodging and burning-in tools may also be used, either alone or in addition to masking.

Combination printing technique. There are several ways to make combination prints. The method below is one of the most reliable. It uses two negatives that are repositioned in the enlarger to make the print.

1. Choose two negatives to make the print. They should both be on the same kind of film and of about the same density. Tape the negatives onto separate negative carriers using black photo tape. Practice placing the carriers into the enlarger accurately, so that the final image will be aligned.

2. Project the first negative onto a piece of white paper. Draw a sketch of the important elements onto the paper. Repeat this procedure with a piece of lightproof cardboard.

3. Remove the first negative. Place the second negative in the enlarger head and project it onto the same piece of white paper. Again, sketch the important elements. Repeat this procedure with the same piece of lightproof cardboard.

4. In addition to the sketches already made, you will need to make cardboard masks to block the major areas of light and dodging tools for fine control of detail areas. Masks can be made by projecting the images onto lightproof cardboard. Use a sharp blade to cut openings as needed in the cardboard. For simple combinations, a single mask will suffice; for complex combinations, you will need a separate mask for each image.

5. Make a separate test print for each negative to determine individual exposure and filtration requirements.

6. To make the finished print, project the first negative onto the photographic paper and make a print at the correct exposure and filtration, while dodging the area needed for the second image. Use the cardboard mask and move it continuously just as you would a dodging tool. This method will produce a soft edge line. Alternatively, set up a masking frame two to four inches above the printing easel, using wooden blocks.

To make the combination print on page 144, two separate enlargers and easels were used. Each transparency was placed in an enlarger, and a test print of each was made. The aerial landscape (above) was exposed at f/16 for 15 seconds; the filtration was adjusted from .10Y .10M to .15Y only. The print was made from a 35mm transparency. The airplanes in formation shot (right) was exposed at f/8 for 15 seconds; the filter pack was .10Y .10M. The print was made from a 70mm transparency. Due to the difference in film size, the enlargers were at different heights. Since each image in a combination print is exposed separately, it is not necessary to stop down the enlarger as in sandwich printing. To make the combination print, the fly-by was exposed first. During the exposure, a mask was moved continuously to block the area where the aerial landscape would be printed. The print was then moved to the second easel and the aerial landscape shot was exposed. The sky was blocked from further exposure by a mask.

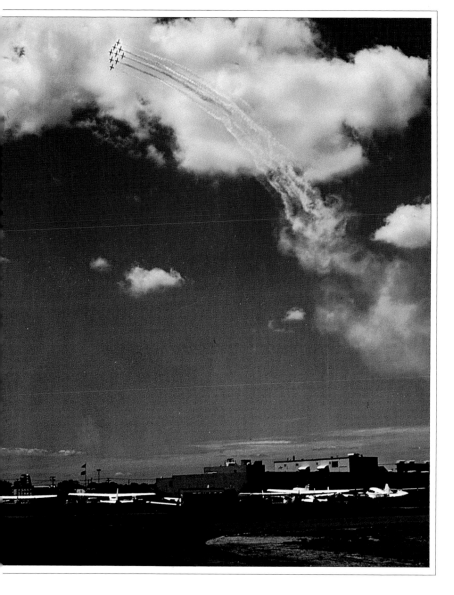

ape the mask in place after checking
he alignment. This method will produce
slightly harder edge line.

7. Project the second image onto the
aper and make a print at the correct
xposure and filtration. During this ex-
osure, use the second mask to block
ght from the area previously exposed

when you made the first print.

8. You will probably need to make
minor adjustments in the alignment, ex-
posure, and filtration. If the enlarger
head must be raised or lowered, or if
exact positioning is needed, use the
sketches made on cardboard to get the
alignment exactly right. After making

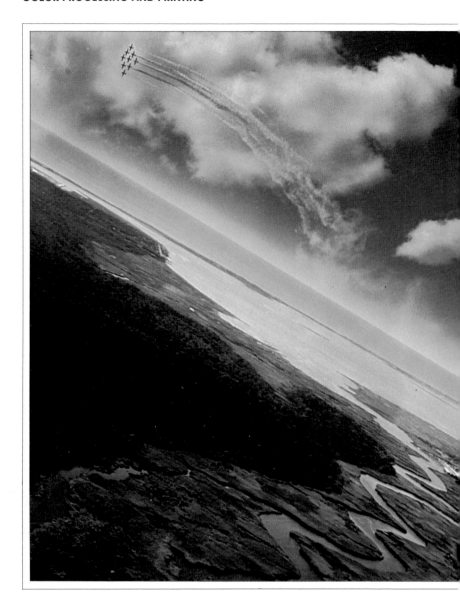

the first exposure, cover the printing paper with the cardboard and project the second image onto it. Adjust the enlarger until the image aligns with the sketch. Do not use a red filter for positioning as is often done in black-and-white printing. This will expose the paper.

If you enjoy combination printing, you may want to start a file of suitable negatives. When shooting negatives for combination printing, try to use the same film for each element in the combination. Shoot to exclude all irrelevant details from the photograph. This will save the need for darkroom manipulations later.

POSTERIZATION

Posterization converts black-and-white or color negatives into graphic images that have a flattened, two-dimensional appearance with large areas of bold, manipulated color. The best posterizations are originally photographed with the final print in mind. Strong, graphic images, without delicate or elaborate detail, work best, since fine details are often lost in the final print.

Films for posterization. The poster effect is created by the elimination of the middle tones through the use of high-contrast black-and-white films. The most common films for masking and posterization are Kodalith Ortho 4556 type 3, or Kodalith Ortho 2556 type 3. (See the chart on page 152 for which film to use when.) Available in 35mm, 4 × 5, and 8 × 10 sizes, Kodalith films are very high in contrast, with strong image definition. Gray tones or gradations of color are dropped out or eliminated entirely from the final image. Since Kodalith films are not sensitive to red, they can be processed under a red safelight. However, this lack of red sensitivity means that color negative and positive films, but not black-and-white films, must have their tonal separations made first on a panchromatic film, which is sensitive to all colors (see the chart on page 152), and then on Kodalith.

Kodalith films are developed in a high-contrast developer. Recommended are Kodalith Fine Line and Kodalith Super RT. The developers are packaged and mixed as two separate working solutions, called parts A and B. The tray life of the developer is short, about one hour. Mix equal amounts of parts A and B immediately before use. Each developer package comes with mixing directions. All Kodalith films come with information on recommended developers, processing times, and agitation instruc-

tions. Follow the directions carefully.

Posterizing with negative film and paper. To make a posterization, a series of high-contrast positives and high-contrast negatives are made onto Kodalith film from the original continuous-tone black-and-white or color negative. To do this, the original negative may be placed in the enlarger and projection-printed onto the Kodalith, or it may be contact-printed onto the Kodalith instead. The resulting positive is then contact-printed onto another sheet of Kodalith in order to reverse the high-contrast image back to a negative. Both the negative and the positive Kodalith images are part of the posterization process. The high-contrast negatives are used to make the final print. The high-contrast positives are needed to mask or block light from previously exposed areas on the printing paper.

Making tone separations. Tonal or density separations usually consist of shadow, midtone, and highlight positives and their corresponding negatives. The shadow positive is made by underexposing the Kodalith, allowing the shadow area to become blocked up and the midtone and highlight areas to remain clear. From this positive a very dense shadow negative is made. The highlight positive is made by overexposing the Kodalith film and then contact-printing it to create a very thin, light, high-contrast negative that records the white areas of the shot. To make the midtone positives and negative, expose the Kodalith normally.

Making the separations. Decide what film size you will use to make your posterization. When working with 4 × 5 or 8 × 10 film, you must immediately adopt a registration system (see page 156). All the film must be marked, or punched, and registered before being enlarged onto the Kodalith; otherwise, the posterization will be out of register. Alternatively, any size film, including

ORIGINAL NEGATIVE

SHADOW POSITIVE

MIDRANGE POSITIVE

HIGHLIGHT POSITIVE

SHADOW NEGATIVE

MIDRANGE NEGATIVE

HIGHLIGHT NEGATIVE

Posterizations require both positive and negative tonal separations made from the original negative. The steps for making the separations are shown here. The original negative (top) is a 35mm black-and-white continuous-tone Tri-X negative. This negative was contact-printed onto Kodalith at varying exposure to make high-contrast shadow (left), midtone (center), and highlight (right) positives. Each positive separation was again contact-printed onto Kodalith at the same exposure time to make shadow (bottom left), midtone (bottom center), and highlight (bottom right) separation negatives.

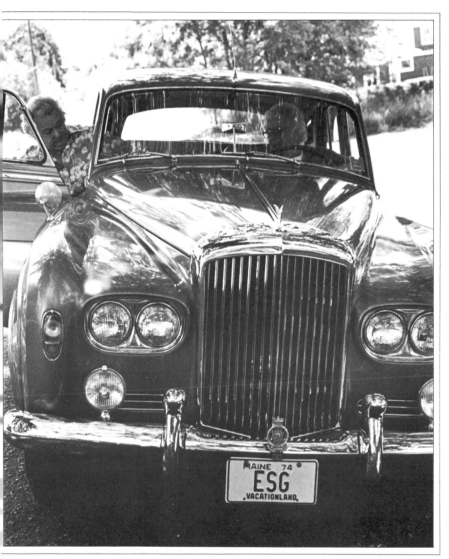

The sequence of Kodaliths on page 146 were used to produce a relatively simple posterization. The original 35mm black-and-white negative produced a continuous-tone black-and-white print (above). Although highlight, midtone, and shadow separations were made, only the midtone negative, highlight negative, and highlight positive were used for the final prints shown here. The highlight negative was taped onto the bottom half of a 35mm negative carrier. The highlight positive and midrange negative were taped together in register, and then taped onto the negative carrier. The separations were placed so that they could be moved separately into position over the negative carrier opening. All three separations were carefully adjusted to be exactly in register with each other. The highlight negative was exposed first at f/16 for 10 seconds with a 1.00M filter pack. The second exposure was made with the midtone negative and the highlight positive at f/8 for 10 seconds with a 1.50 filter pack. The additional exposure was needed to cut through the very dense highlight positive. The end result is the striking print on page 148.

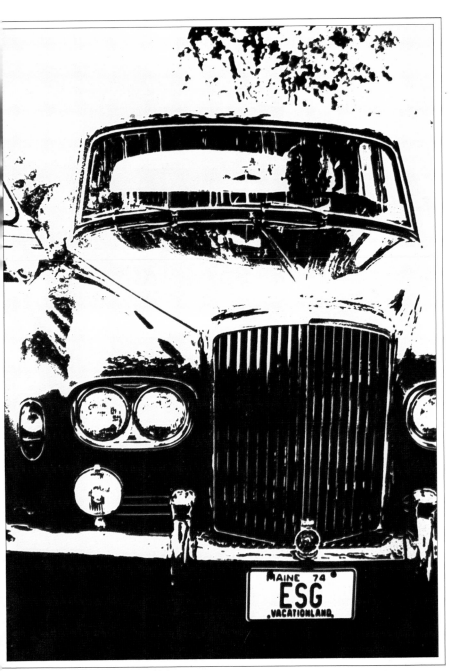

Posterization variations are easily produced. The print above was made using the midtone negative alone. The exposure was f/16 for 10 seconds; the filter pack was 1.50Y. In the print on page 150, the shadow negative was printed first, using a 1.50Y filter pack. The second exposure was made using the highlight negative and midtone positive as a mask. Where the yellow and purple tones overlapped, green was produced. A third variation (page 151) was made by printing the highlight negative first. The exposure was f/8 for 10 seconds; the filter pack was 1.50Y. The second exposure was made using the highlight positive and midtone negative. The exposure was f/8 for 10 seconds; the filter pack was .60M 1.50Y.

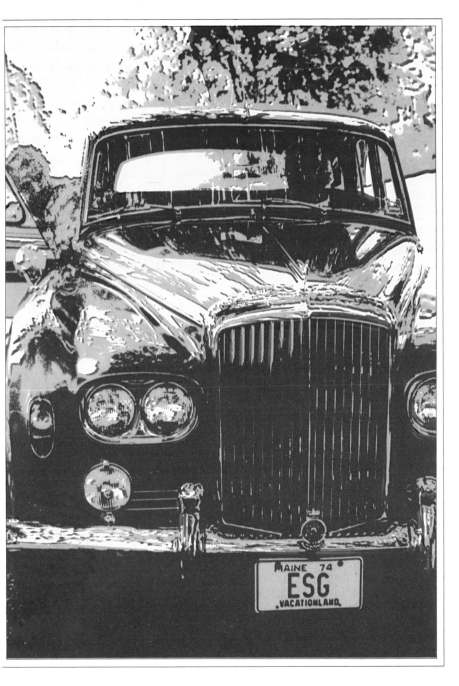

KODAK HIGH-CONTRAST FILMS

Original Film	To Make a High-Contrast Positive Use:	To Make a High Contrast Negative Use:
Black-and-white negative	Kodalith Ortho 4556 type 3 Kodalith Ortho 2556 type 3 Professional Line Copy Film 6573	Kodalith Ortho 4556 type 3 Kodalith Ortho 2556 type 3 Professional Line Copy Film 6573
Color negative	Kodalith Pan Film 2568	Kodalith Ortho 4556 type 3 Kodalith Ortho 2556 type 3 Professional Line Copy Film 6573
Color positive	Kodalith Ortho 4556 type 3 Kodalith Ortho 2556 type 3 Professional Line Copy Film 6573	Kodalith Pan Film 2568

35mm, may be contact-printed onto the Kodalith to make the separations. It is easy to register 35mm or 2¼ separations and tape them onto the negative carrier for printing the posterization. The steps for making the separations are listed below.

1. Place the negative in the carrier, or on the Kodalith film, *emulsion-side up*. Since posterization is a two-step process, it is necessary to reverse the negative at this stage so that the final image will read properly.

2. Make a series of six to eight test exposures for five seconds each, varying the aperture by half-stop increments. This will help you determine the correct exposures for the shadow, midtone, and highlight separations. Process the Kodalith film normally.

3. Make three separation positives, using the exposure information derived from the test. The midtone positive is made at the normal exposure; the shadow positive is underexposed by one to three f-stops; the highlight positive is

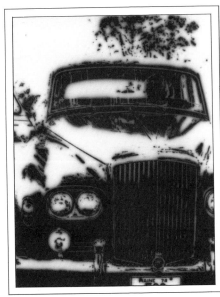

Two very common posterization errors are shown here. Above is an overexposed Kodalith positive. Note the weak, fuzzy edge lines. This positive would produce a very poor negative. At right is a posterization that is out of register.

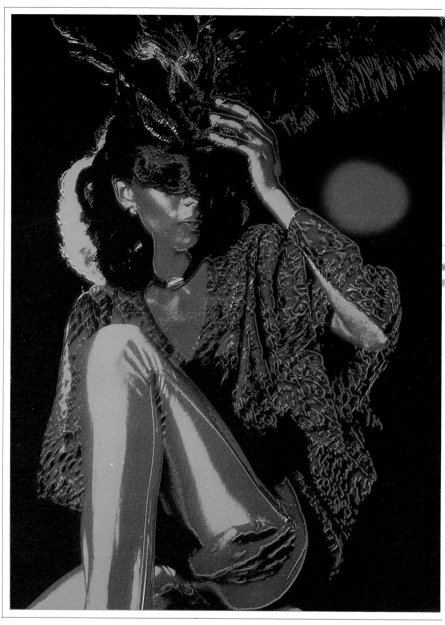

Posterizations can be made directly onto color positive paper. When starting with a black-and-white negative, make three separation positives. These will be used for the exposure. You will also need separation negatives for masking. Jim Collier photographed Dana on Tri-X against a black, backlit background. He contacted the negative onto Kodalith to obtain midtone and shadow positives. A midtone separation negative was then made. The print was made on 11 × 14 Cibachrome paper. The separations were registered on a sheet of glass cut to fit the carrier station. To make the final image the shadow positive was printed with a blue filter to produce the dark blue areas. The midtone positive was then printed using the blue filter but overexposing by one stop to produce the light blue areas. The midtone negative and midtone positive were then printed slightly off register. By using a red filter and overexposing by one stop, red hairlines were produced. A board with a hole cut in it created the spots of red in the upper right and the bottom

KODALITH PROBLEMS AND CAUSES

Problem	Cause
Clear areas have gray tone, especially at edges; clear edges are broken or poorly defined	Overexposure
Black areas are too large	Overexposure
Clear areas are too large	Underexposure
Image is gray, not black	Underexposure
Streaking or muddy areas	Underdevelopment or insufficient agitation

overexposed by one to three f-stops. Process the Kodalith film normally.

4. Contact-print the three separation positives onto Kodalith film, *emulsion to emulsion*, to make the separation negatives. Determine the correct exposure for the midtone negative by making an exposure test. Do *not* vary the exposure for the different separations. All three negatives are contact-printed *for the same time*.

5. Examine the three positive and three negative Kodaliths. Retouch all pinholes in the emulsion using red opaque and a thin brush.

6. Place any combination of positive and negative separations in register, and prepare for printing the posterization.

Correctly exposed and processed Kodalith images have sharp-edged clear areas and opaque black areas. See the chart on page 155 for common Kodalith problems and their causes.

Printing the posterization. Combinations of the negative and positive masks can be projected or contacted onto color printing paper for an almost endless variety of results. The number of colors in a posterized print is determined by the number of pairs of negatives and positives used. Printing a standard three-color posterization is described below. This is only one possible combination of positive-negative masks. Other variations

can easily be made, and several are illustrated in this chapter. It is best, however, to make your first posterizations using only one pair of masks. Experience and experimentation are the best ways for determining what works.

1. Register all the positives and negatives, either on an easel or pin-registration stand, or with tape on the easel or in the negative carrier.

2. Make a test print using the midtone negative to determine the correct exposure for the color printing paper.

3. Set the color filtration on the enlarger, remembering that with negatives you achieve a color by using its complementary filter. Based on the information from the test print, make the first exposure using the shadow mask.

4. The second exposure is made with a different filter pack using both the midtone negative and the shadow positive in register. The shadow positive masks the area of the printing paper previously exposed through the shadow negative. This prevents these areas from being affected during the second exposure with the midtone negative.

5. A third exposure is made using a different filter pack with the midtone positive and the highlight negative in register. The midtone positive masks the areas of the printing paper previously exposed using the shadow and midtone negatives.

6. If desired, a specific color may be placed in the background by exposing with the highlight positive in place and a new filter pack.

REGISTRATION TECHNIQUES

Posterization requires printing several images on one piece of film in sequence and in perfect alignment or registration.

A punch system is the simplest registration method when working with 4 × 5 or 8 × 10 film. Although a professional registration punch can be purchased, a simpler and less expensive method is to use a standard office paper punch. Make sure the punch you use is sturdy enough to go through plastic sheet film without tearing or buckling the film. You will also need a registration easel and registration pins. The easel can be made simply by painting a piece of board flat black. Registration pins can be purchased for very little from dealers in printing supplies. The pins are metal, about ¼-inch high and ¼-inch wide (the same width as most standard paper punches). Punch two holes at the top of a scrap piece of Kodalith to make a template. Using the template, tape or glue the registration pins to the board. When you make separation masks and print posterizations, punch holes in each piece of film and paper using the template. This will ensure that your posterization registers properly.

Separations on 35mm or 2¼ film can be taped in sequence onto the bottom half of a negative carrier or onto a piece of glass. Align the separations using a light box and loupe. Tape them in place on the negative carrier. Make sure you can lift each piece of film in and out of the carrier easily. This can be done by scoring the tape or making a tape hinge on each piece of film. Tape the negative carrier onto the carrier station so that it cannot move as you change the separations. If it does, your posterization will be out of register.

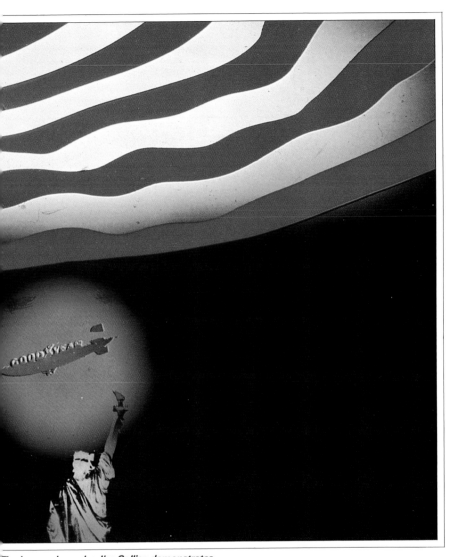

The image above, by Jim Collier, demonstrates
multiple printing in conjunction with
posterization. A set of positive and negative
separations was made for each subject within
the image — the stars, the stripes, the zeppelin,
and the Statue of Liberty — to produce this
unusual and very dramatic print.

Posterizations can be made by photographing Kodalith separations on a lightbox using various filters. Joel Aaronson's sensuous posterization started out as a continuous-tone black-and-white negative. He made a series of high-contrast negatives and positives on 8 × 10 Kodalith film. He then taped the highlight, midtone, and shadow positives and a midtone negative and background mask together in register and placed them on a lightbox. Red, blue, and green filters were placed over different separations. The separations were then photographed onto the same piece of 35mm daylight transparency film. Where the red and green filters overlap, yellow is produced. The blue and red filters produce magenta highlights in the hair. Throughout the three exposures, the background mask was kept in place. For the fourth exposure, the background mask was removed, and with the other separations in place, the exposure was made through a magenta filter.

8

Darkroom Equipment

HE ENLARGER IS THE MOST IMPORTANT PIECE
f equipment in the darkroom. The bet-
:r it is, the more variables it controls
nd easier it is to use. Ask yourself three
uestions when choosing an enlarger:
)oes it fit my work (creative printing,
opywork)? Does it offer growth (larger
ormats and enlargement sizes)? Does it
ontrol the most variables for the
xpense?

Diffusion dichroic enlargers. In a dif-
usion dichroic enlarger, nonfading di-
hroic filters are inserted into the white
ght source (usually a quartz-halogen
amp) to produce colors. The colors are
tepped onto the glass in increasing den-
ity, and a dial on the enlarging head al-
ows easy filtration control. This type of
nlarger has another advantage: the light
asses through a mixing chamber, so a
hange in the filtration does not require
compensating change in the exposure
ime. The diffusion enlarger is some-
vhat softer in contrast when compared
o a condenser enlarger, and it also cam-
uflages dust on the negative, so prints
equire little or no spotting.

Condenser enlargers. In a condenser
nlarger, the light from the enlarger
amphouse passes through large glass
enses called condensers. These lenses
ocus the light rays, causing them to
roduce crisper, more contrasty prints.
Most experienced black-and-white
rinters already own condenser enlarg-
rs. To work in color without much ad-
itional expense, color printing filters
an easily be placed in the filter drawer
f the enlarger or below the lens. Ace-
ate filters are fine for use in the drawer;
owever, fading, scratches, dust, and
ny imperfections will be noticed if they
re placed in front of the lens. Purchase

only high-quality gelatin filters or CC
filters. High-quality color prints can be
made using a condenser enlarger. How-
ever, it is slower, less accurate, and more
time-consuming when working with dif-
ferent filter packs. All adjustments in
filter packs will require exposure adjust-
ments (see the chart on page 000). In ad-
dition to color printing filters, a heat-
absorbing glass, and an ultraviolet filter
will also be needed. An alternative to all
this is to convert a black-and-white en-
larger by purchasing an interchangeable
color head.

Enlarger size and lenses. Enlargers are
designed to accept different sizes of
film. If you shoot only 35mm, one of
the smaller enlargers will probably satis-
fy you. However, you will have more
versatility if you purchase an enlarger
that also accepts larger film sizes. To get
enough covering power, each film for-
mat requires the appropriate focal-
length lens. Use a 50mm lens for 35mm
film, a 75mm or 80mm lens for 2¼ to
3¼ film, and a 125mm lens for 4 × 5
work. Enlarging lenses, which are sold
separately, are vitally important. A poor
lens will give you unsharp images and
edge distortion. However, an excellent
lens can easily upgrade the quality of
your prints. The lens should be color-
corrected and have the correct adapting
mount for your enlarger.

When purchasing an enlarger, test it
for sturdiness. One that wobbles or
shakes will cause the print to appear out
of focus. Generally, the larger the for-
mat the enlarger accepts, the sturdier,
larger, and more costly it will be.

All enlargers for color work require
voltage stabilizers; many also require a
power supply. Voltage stabilization is

essential to keep the enlarging bulb and timer from being subjected to fluctuations of household power.

ADDITIONAL EQUIPMENT

You will also need negative carriers, a printing easel, and a timer. The new digital timers allow for partial-second exposure times, store up to ten timing steps in sequence, and are extremely accurate.

So many products are available for film and paper processing that it becomes difficult to separate the essentials from the nonessentials. It is more important to purchase high-quality essentials than a host of gadgets. Since darkroom needs change, think through all purchases wisely.

Film processing essentials. The following list gives the basic darkroom equipment needed for processing negatives and transparencies.
- Daylight developing tank and film-loading reels, made from plastic or stainless steel
- Storage containers for each chemical solution
- Graduates or measuring containers in one quart, half-gallon, and gallon sizes.
- Photographic thermometer designed for color work
- Mixing rod
- Rubber gloves
- Processing trays
- Negative sleeves and slide mounts
- Film drying clips and white nylon cord.
- Film washer or washing tray

Paper processing essentials. In addition to the bottles for storages, measuring and graduate containers, thermometer, and rubber gloves needed for film processing, you will also need:
- Daylight print-processing drums (at least two)
- Motorized processing-drum base
- Set of 8×10 or 11×14 print-processing

trays (if you don't use the drum system
- Processing timer
- Drying rack, blotter book, hairdrye or any system that will dry prints safe
- Washing trays or a paper-washir system
- Squeegee

DARKROOM SPACE

The last item to consider is the dar room space you have. For many peopl having a darkroom usually means adap ing a small area in a kitchen or bath room on a temporary basis, and disma tling it and returning it to its origin function after each working sessio This is a discouraging and unproductiv way of doing things. Anyone seriou about photography should consider a ternative means.

For apartment dwellers, a large clos (preferably walk-in) or a dressing are can become an ideal work space. A cab net unit or shelving can easily be adde The room can be permanently set u and blacked out. Only very small roon will require additional ventilation. Ru ning water is not essential, but a larg stable work table is. Be sure it is larg enough to hold trays and a water bath

Basements, attics, or any availabl room can make spacious darkroom Black out the area and be sure it is ver tilated. If possible, divide the darkroor into wet and dry sides. Place th enlarger on the dry side. A light box an space for film loading, negative sortin and dry mounting should also be on th dry side. The wet side is reserved for a processing involving chemicals, we prints, and wet films. Tanks, trays, reel and a wet or dry sink are also foun here. Never mix the dry and wet side Finished negatives and prints can b damaged by the chemistry.

DARKROOM SAFETY

For your own safety and that of others pay close attention to darkroom safety

Keep all chemicals securely stored and way from children.
Keep electrical cords dry.
Ground all electric equipment.
Run extension cords along the walls, ot across the center of the darkroom. (any darkroom accidents are caused by ipping over wires.
Wipe up chemical spills immediately.

• Ventilate the darkroom.

A darkroom need not be costly or extensively equipped. However, a darkroom that does not have adequate space and good basic equipment will soon discourage its user. With a bit of planning, your darkroom will become another valuable tool that will be of great help in your creative photographic effort.

Technical Tables

RECIPROCITY FAILURE CORRECTIONS

When working with very long exposure times, reciprocity failure becomes an important factor. Use the table below to determine the filtration and exposure changes needed for most popular films.

Compensations for Indicated Exposure Time (in seconds)

Film Type	1/10	1	2	10	64	100
Kodachrome Professional Type A	½ stop, no filter	½ stop no filter		1 stop, CC10Y		*
Ektachrome 64		½ stop, CC15B		1 stop, CC20B		*
Ektachrome 200		½ stop, CC10R		*		*
Ektachrome 160		½ stop, CC10R		1 stop, CC15R		*
Kodachrome 25		1 stop, CC10M		1½ stops, CC10M		2½ stops, CC10M
Kodachrome 64		1 stop, CC10R		*	*	*
Fujichrome 100		⅓ stop, CC05C	⅔ stop, CC05C	⅔ stop, CC10C	1⅔ stops, CC20C	2 stops, CC20C
Kodacolor II		½ stop, no filter		1½ stops, CC10C		2½ stops, CC10C + CC10G
Kodacolor 400		½ stop, no filter		1 stop, no filter		2 stops, no filter
Vericolor II Professional Type S		*		*		*
Fujicolor II		⅓ stop, no filter	⅔ stop, no filter	1 stop, no filter	1⅓ stops, no filter	1⅔ stops, no filter
Fujicolor II 400		1 stop, no filter		2 stops, no filter		3 stops, no filter

*Not recommended

LIGHTING RATIO TABLE

This table compares the lighting ratio (the range between the lightest and darkest areas of a scene) to the equivalent difference in f-stops.

Stops Difference	Lighting Ratio
⅔	1.5:1
1	2:1
1⅓	2.5:1
1⅔	3:1
2	4:1
2⅓	5:1
2⅔	6:1
3	8:1
3⅓	10:1
3⅔	13:1
4	16:1
5	32:1

CHANGING THE LIGHTING

When working with studio lights or with on-camera flash in ambient light, there are two ways to change the intensity of the illumination: change the location of the light source, or change its intensity. It is generally much easier to move the light. Consult the table below to find the subject-to-light-source distances needed for the indicated changes in the amount of illumination.

To Increase Light Intensity By:	Divide Subject-to-Light-Source Distance By:
1 stop	1.4
2 stops	2
3 stops	2.8
4 stops	4
5 stops	5.6

To decrease light intensity, use the chart above, but multiply the subject-to-light-source distance by the factors shown.

COLOR PRINTING PAPERS

Negative-Positive	Surfaces	Comments
Kodak Ektacolor 74	G, L, M, Y,	Lower contrast
Kodak Ektacolor 78	G, L, M, Y,	Higher contrast
Kodak Ektaflex PCT (negative)	G, M	Diffusion transfer
Agfacolor	G, L, M	Available in Europe only
Unicolor	G, L, M	Process in Unicolor chemistry only

COLOR PRINTING PAPERS

Positive-Positive	Surfaces	Comments
Kodak Ektachrome R-14	G, L	Chromogenic paper
Kodak Ektachrome 2203	G, L	Recently discontinued — replaced by R-14
Ektachrome 22	G, L	New paper — process in new R-3 chemistry
Ektachrome 21	G, L	New paper — for making prints using new R-3 chemistry
Kodak Ektaflex PCT (positive)	G, M	Diffusion transfer
Ilford Cibachrome AII	G, L, M	Silver dye-bleach
Agfacolor	G, L, M	Available in Europe only
Agfachrome Speed	G	Recently introduced diffusion transfer paper

G = glossy; L = luster; M = matte; Y = silk

COLOR PRINT DEVELOPER KITS

Negatives

Process	Comments
Kodak Ektaprint	Designed for Ektacolor 74 and 78 papers
Beseler 2-Step	Offers many processing temperatures
Parcolor	No temperature control needed
Unicolor 2-Step	Offers many processing temperatures
Unicolor Total Control	Processes both film and paper
Photocolor II	Available in Europe only; processes both film and paper.

Positives

Process	Comments
Kodak Ektaprint R1000	Designed for Kodak 2203 and R-14 paper
Kodak Ektaprint R-3	Designed for new Ektachrome 21 and 22 papers
Beseler 3-Step	Offers wide range of working temperatures
Unicolor RP1000	Designed for Kodak R-14 paper
Ilford P-30	Designed for Cibachrome

COLOR PROCESSING KITS

C-41 Process

Kit	Comments
Kodak Flexicolor	Industry standard
Beseler CN2	Choice of three processing temperatures, including room temperature
Unicolor K2	Mix only exact amount needed
Unicolor Total Color	Processes both film and paper
Parcolor P-41	
Patterson Acucolor 2	Requires continuous agitation
Photocolor II	No temperature control required; available in Europe only; processes both film and paper.
Opticolor	Available in Europe only
Agfacolor Process F	Recently introduced in United States
LoTemp COLOR 41	Recently introduced
RT Color Negative Process	Process at room temperature

E-6 Process

Kit	Comments
Kodak E-6	Industry standard
Beseler E-6	Seven chemical steps
Unicolor Rapid E-6	Three chemical steps
Unicolor Standard E-6	Seven chemical steps
LoTemp Chrome 6	Recently introduced
RT E-6	Recently introduced

167

Further Reading

Casagrande, Bob. *Better Black-and-White Darkroom Techniques.* Englewood Cliffs, N.J.: Prentice-Hall, 1982.

Eastman Kodak Co. *Color Darkroom Dataguide.* Rochester, N.Y., 1982.

Eastman Kodak Co. *Kodak Color Films.* Rochester, N.Y., 1980.

Eastman Kodak Co. *Creative Darkroom Techniques.* Rochester, N.Y., 1973.

Eastman Kodak Co. *Kodak Workshop Series: Using Filters.* Rochester, N.Y., 1981.

Gassen, Arnold. *Handbook for Contemporary Photography.* Athens, Ohio: Handbook Publishing Co., 1974.

Hedgecoe, John. *The Photographer's Handbook.* New York: Alfred Knopf, 1977.

Holloway, Adrian. *The Handbook of Photographic Equipment.* New York: Alfred Knopf, 1981.

Horenstein, Henry. *Black & White Photography: A Basic Manual.* Boston: Little, Brown & Co., 1976.

Horenstein, Henry. *Beyond Basic Photography.* Boston: Little, Brown & Co., 1977.

Krause, Peter and Henry A. Shull. *The Complete Guide to Cibachrome Printing.* New York: Ziff-Davis Books, 1980.

Langford, Michael, *The Book of Special Effects.* New York: Alfred Knopf, 1982.

Logan, Larry. *The Professional Photographer's Handbook.* Los Angeles: Logan Design Group, 1980.

Marvullo, Joe. *Improving Your Color Photography.* Englewood Cliffs, N.J.: Prentice Hall, 1982.

Morgan & Morgan Darkroom Book. Dobbs Ferry, N.Y.: Morgan & Morgan, 1977.

Nettles, Bea. *Breaking the Rules: A Photo Media Cookbook.* Rochester. N.Y.: Light Impressions, 1980.

Schofield, Jack. *The Darkroom Book.* New York: Ziff-Davis Books, 1981.

Stone, Jim. *Darkroom Dynamics.* Somerville, Mass.: Curtin & London, 1979.

Vestal, David. *The Craft of Photography.* New York: Harper & Row, 1974.

Zakia, Richard D. and Hollis N. Todd. *Color Primer I & II.* Dobbs Ferry, N.Y.: Morgan & Morgan, 1974.

Glossary

Acetate. A clear, inflammable material used as a base for film and color filters.

Acetic acid. An acid used in stop baths and acid fixers. It is usually used in a diluted form.

Activator. A chemical solution that starts development and release of dyes — used in diffusion transfer processes.

Acutance. An objective measurement of image sharpness, based on how well an edge is recorded in the photograph. An image with a high accutance would appear sharper and more detailed than an image with a low accutance.

Additive color. Color produced by light in the primary colors blue, green, and red, either singly or in combination. Combining all three primary colors produces white light. Additive color is the principle behind color television.

Additive printing. A printing process that utilizes the principles of additive color. Red, green, and blue filters are used one at a time during the exposure, for appropriate color filtration. Also called tricolor printing.

Agitation. The technique of ensuring even processing by moving the film or paper within the processing solution, or stirring the solution itself.

Air bubbles or bells. Bubbles of air that are formed during film or paper processing and remain on the film, causing uneven development. Can be avoided by proper agitation.

Ambient temperature. Room temperature, or the temperature of the chemistry after it has been left at room temperature for at least one hour.

Anti-halation layer. A thin emulsion layer found in film, designed to prevent light striking the film base from reflecting back into the emulsion layers and causing halation in the image.

Aperture. Opening in the lens that admits light. Usually variable in size, it is calibrated in f-numbers. Its size affects the amount of light striking the film as well as the sharpness of the image.

ASA. American Standards Association. The sensitivity of a film to light (its speed) is measured by the ASA standard. A new standard has recently been adopted — see ISO.

Backlighting. Light directed toward the camera from behind the subject.

Base. Support for the photographic emulsion. Films use an acetate base, printing papers a paper base.

Baseboard. The board on which an enlarger stands; any board used as a base for photographic paper.

Black silver. Metallic silver formed from silver halides during exposure and development.

Bleach. A chemical bath that reacts with the black silver formed by the developer, either by dissolving it or turning it back to silver salts.

Bleach-fix or blix. Chemical bath used in color processes in which the bleach and fixer have been combined.

Blocked-up. Describing an overexposed or underdeveloped area of a negative that prints as a light, undetailed area.

Bracketing. Making a series of exposures of the same subject, varying the exposure in increments around the estimated correct exposure.

Brightness. A subjective, comparative measurement of luminance.

Brightness range. The difference in brightness between the darkest and lightest areas of a scene or image.

Brilliance. The intensity or luminosity of light reflected from a surface; a characteristic of photo paper having clear, bright highlights and a good range of tones.

Burning-in. The technique of giving additional exposure to selected parts of an image during printing.

CC filters. Color correcting filters, available in assorted colors and with densities ranging from .05 to .50.

Chemical capacity. The amount of film or paper that can be processed in a specific chemical before it is exhausted and must be replaced or replenished.

Chroma. In the Munsell system of color classification, the saturation (purity) of a color.

Chromogenic development. Common developing process for many photographic materials. The color developer combines with color couplers to form specific dyes.

Clip test. Short sample of film developed to determine the correct time for entire roll.

Color balance. An adjustment of color materials, usually using additional color filtration, to eliminate a particular color bias or color cast.

Color cast. An overall tint in an image, caused by light sources that do not match the sensitivity of the film, by reciprocity failure, or by poor storage or processing.

Color couplers. Components in color films and papers that react with the processing chemicals to produce specific dyes, giving the color to the photographic image.

Color head. An enlarger illumination system that has built-in color filters, which are adjustable for color printing.

Color sensitivity. The specific response of color materials to light of different wavelengths.

Color temperature. A system for measuring the color quality of a light source by comparing it to the color quality of light emitted when a theoretical black body is heated. Color temperature is measured in degrees Kelvin.

Combination printing. The technique of sandwiching two negatives together and then printing them.

Complementary colors. A pair of colors that, when mixed together by the additive process, produce white light.

Condenser. A simple, one-element lens found in enlargers and used to converge the light and focus it on the back of the enlarger lens.

Conditioner. A chemical used in E-6 film processing.

Contact print. A print created by placing the negative(s) in direct contact with the printing paper. No enlarger lens is necessary.

Continuous tone. Reproducing or capable of reproducing a range of tones from pure black to pure white.

Contrast. The difference between tones in an image.

Copy negative. A negative produced by copying a print or original negative used for printing.

CP filters. Color printing filters, acetate filters that are used in the filter drawer of the enlarger for color printing.

Cropping. Selecting a portion of an image for reproduction in order to modify the composition.

Cyan. A blue-green color, the complement of red; one of the three subtractive primary colors.

Daylight film. Color film designed to be used outdoors, or with a light source of equivalent color temperature, balanced to $5500°K$.

Daylight tank. Lighttight container made of plastic or stainless steel used for film development. Film is loaded into the tank in the dark; once the tank is capped all processes can be carried out in normal room light.

Data sheet. The information sheet packed with all photographic materials; a record of film or print processing, according to a specific system.

Dense negative. A negative that is darker than normal, usually due to overdevelopment or overexposure.

Density. The ability of a developed silver deposit on a photographic emulsion to block light. The greater the density of an area, the greater its ability to block light and the darker its appearance.

Density range. The difference between the minimum density of a print or film and its maximum density.

Developer. A chemical solution that changes the latent image on exposed film or paper into a visible image.

Dichroic filters. Interference-type filters built into the enlarger head and used to determine color balance when printing.

Diffraction. The scattering light waves as they strike the edge of an opaque material.

Diffused image. An image that appears to be soft and has indistinct edges, generally created by shooting or printing with a diffusing device.

Diffusion enlarger. Enlarger illumination that scatters the light from many angles evenly over the surface of the negative, producing a softer image without scratches or dust marks.

Diffusion transfer. A method of printing where the image is exposed onto a piece of film, placed into an activator solution, then transferred or laminated onto a piece of receiving paper where the color dyes are released.

Direct positive printing. System for making color prints from color transparencies using positive printing paper. Also called R or reversal printing.

Dodging. The technique of giving less exposure to selected parts of an image during printing.

Drying marks. Marks occasionally left on processed film after it dries. They can be avoided by use of a wetting agent and removed by careful rewashing.

Easel. A frame for holding printing paper flat during exposure.

Emulsion. A light-sensitive layer of silver halide salts suspended in gelatin and coated onto a paper or film base.

Enlargement. A print made from a smaller negative.

Enlarger. A device used to project and enlarge an image of a negative onto photographic paper or film.

Exposure. The amount of light allowed to reach a photographic emulsion.

Exposure latitude. The maximum change in exposure from the ideal exposure that will still give acceptable results.

Fast film. A film that has an emulsion that is extremely light sensitive, allowing photographs to be taken in low illumination. These films have a high ISO/ASA number.

Filter factor. The increase in exposure needed when filters are placed in front of the lens.

Filtration. The use of color filters in printing to control the color balance of the final enlargement.

Fixer. A chemical solution that dissolves the remaining silver halides in an image, making it permanent.

Flare. Stray light, not part of the image, that reaches the film in the camera because of scattering and reflection within the lens.

Flatness. Lack of contrast in an image, caused by overly diffuse light, underdevelopment or underexposure, or flare.

Fog. Density on a photographic emulsion caused by accidental exposure to light or by processing chemicals and not part of the photographic image.

Fogging. In the camera, deliberately exposing the film to unfocused light, either before or after photographing a subject, in order to reduce contrast. In the darkroom, a usually accidental development of the film or paper because of something other than exposure (e.g., chemical contaminants).

Format. The specific size of film, printing paper, or camera-viewing area.

F-stop. Number indicating the relative size of the lens opening or aperture setting. Each setting progressively halves or doubles the brightness of the image.

Gelatin. The substance in an emulsion in which the light-sensitive particles of silver halide are suspended.

Gelatin filters. Colored filters that provide strong overall color effects.

Glossy paper. An extremely smooth type of photographic paper giving a great range of tones from pure white to pure black.

Gradation. The range of tones, from white to black, found in a print or negative.

Grain. The pattern or pebblelike appearance of black metallic silver on film, which is formed when silver halides have been exposed and developed. Slow films have a smaller grain structure, fast films a larger grain structure.

Gray card. A piece of gray cardboard with one side having 18 percent reflectance when measured by a light meter. Used as

an aid for metering, this gray is the standard medium tone.

Gray scale. A series of patches, joined together, of shades of gray ranging from white to black in equal increments.

Halation. The undesirable effect created when light passes through an emulsion, strikes the backing, and is reflected back through the emulsion, reexposing it.

Half-stop. The intermediate lens opening between two standard f-stops; e.g., f/8½ falls between f/8 and f/11.

Hardener. A chemical, usually incorporated into the fixer, that causes an emulsion to harden while drying, making it less susceptible to damage.

High-contrast paper. Photographic printing paper with a great deal of contrast, generally about grade 4.

Highlight mask. An intermediate positive or negative created to retain the highlights when duplicating.

Highlights. The areas of a photograph that are only barely darker than pure white.

Hot spots. A part of a scene or photograph that is relatively over-lit, often caused by poor placement of lights.

Hue. The name of a color.

Hypo. Another name for sodium thiosulfate or fixer.

Hypo clearing bath (eliminator). A chemical solution used to shorten the washing time needed after fixing.

Illumination. The amount of light falling on a subject.

Indoor film. Color film that has been balanced to give an accurate rendition of tones under indoor tungsten illumination — 3200° to 3400°K.

Infrared film. Film sensitive to the infrared end of the spectrum, beyond the light visible to the human eye.

Internegative. A negative made from special copy film used to make copy prints from color transparencies. Internegative film has a built-in mask to control contrast.

ISO. International Standards Organization. The new international film speed system, which incorporates the ASA (American film speed) and the DIN (European film speed) numbers into a more universal set of numbers.

Kelvin. The unit used to measure color temperature; the Celsius temperature plus 273.

Latent image. The invisible image that forms on the film after it has been exposed to light. Developer changes the latent image into a visible image.

Latitude. The amount of over- or underexposure a photographic emulsion can receive and still produce acceptable results.

Light box. A box used for viewing, registering, or assessing films, usually made of daylight-balanced fluorescent bulbs covered with translucent glass or plastic.

Lighting ratio. A comparison of the amount of light falling on one side of the subject with the amount falling on the other side.

Line print. An outline effect created by sandwiching a positive and negative Kodalith of the same image and then making the print by passing light through the sandwich at a 45-degree angle.

Lith developer. A developer designed specifically for lith films.

Lith film. A very high-contrast film emulsion used for a number of darkroom special effects; Kodalith is the best-known brand.

Local control. The ability to control tones and color through dodging and burning-in specific areas of the image.

Luminance. The brightness of a light

Magenta. One of the three subtractive primary colors; the others are cyan and yellow.

Mask. A device used to modify or hide part of an image during printing.

Matte. A descriptive term for any surface that is relatively nonreflective.

Midtone or midrange. Those tones in a scene that fall midway between the darkest and lightest tones.

Montage. A composite picture made by combining elements from different photographs together.

Mottle. Developing fault characterized by

streaking or density changes on paper or film.

Multiple exposure. Two or more exposures made on the same piece of printing paper or film.

Multiple printing. Two or more negatives used to make one print.

Munsell system. A systematic method of color classification based on the three dimensions of color: hue (the name of the color), value (its lightness), and chroma (its saturation).

Negative carrier. A holder used to position the negative correctly between the enlarger light and the enlarger lens.

Neutral density. Gray, colorless density caused by using three subtractive color filters at once. To remove neutral density, remove the least dense filter, and adjust the filter pack by subtracting an equivalent amount from each filter left.

Neutral density filter. A filter, available in varying intensities, that reduces the amount of light reaching the film without affecting its color.

Neutralizer. A chemical used in color processing to counteract or stop the effects of another chemical solution.

Newton's rings. A circular interference pattern that occurs when negatives come into partial contact with a glass negative carrier.

One-shot solution. Any processing solution designed to be used only once and then discarded.

Opaqueing. 1. The technique of covering parts of a negative with an opaqueing solution to block out the image in that area. 2. To fill in pinholes in Kodalith negatives or positives with an opaqueing solution.

Orthochromatic. An emulsion, either paper or film, that is sensitive to green, blue, and ultraviolet light and can be handled under a dark red safelight.

Overdevelopment. Development for longer than the recommended time.

Oxidation. The exhaustion of processing chemicals due to a reaction with air or with silver halides.

Panchromatic. Sensitive to all the colors of the visible spectrum.

Posterization. A high-contrast printing procedure producing a print with only two or three (sometimes more) tones.

Presoak. The process of soaking film or printing paper in water right before development to prevent uneven development.

Primary colors. Any three colors that can be combined to make any other color. In additive color, the primary colors are red, green, and blue; in subtractive color, the primary colors are yellow, magenta, and cyan.

Printing frame. A frame used to hold the negative and paper together when exposing a contact print.

Pull processing. Intentional underdevelopment of a film or paper, usually because it has been overexposed.

Push processing. Intentional overdevelopment of a film or paper, usually because it has been underexposed.

Quartz-halogen lamp. A tungsten-balanced enlarger light that burns brightly and evenly with consistent color temperature over a long period.

Reciprocity failure. During very long or very short exposures, the law of reciprocity no longer holds and film shows a loss of sensitivity, resulting in underexposure, and color changes in the case of color film.

Reciprocity law. The amount of exposure a film receives is the product of the intensity of the light (aperture) times the exposure time (shutter speed). A change in one is compensated for by a change in the other.

Reducer. A chemical solution used to reduce the density of a negative or print.

Register punch. Hole punch used to make registration holes on film or paper for alignment purposes.

Registration. Exact alignment of several negatives, pieces of film, or images on photo paper to make an accurately combined image.

Replenisher. A solution added to a larger amount of the same solution to maintain its strength as it is depleted by use.

Resin-coated (RC) paper. Photographic printing paper with a plastic backing. RC paper dries quickly without curling.

Reticulation. A crazed pattern of cracks in the photographic emulsion, caused by a sudden change of temperature during processing.

Retouching. Additional treatment of a print or negative by hand to remove spots and scratch marks or to add supplemental color.

Ringaround. A series of color prints from one negative or transparency that shows the effect of filtration changes. Used to assess color filtration errors.

Sabattier effect. The appearance of areas of both a positive and negative image on a film or paper, caused by brief exposure to light during development.

Safelight. A colored light that does not affect the photographic material in use. E.g., a dark-red light used when processing orthochromatic film.

Sandwiching. The combination of two or more negatives in the negative carrier when printing.

Saturated color. Rich, pure color hue undiluted by gray.

Saturation. The purity of a color; the more white light the color contains, the less saturated it is.

Secondary color. In photography the colors yellow, magenta, and cyan, which are complementary to the primary colors red, green, and blue. Two secondary colors mixed in equal proportion will form a primary color.

Shadow detail. Details visible in the darkest portion of a print or slide.

Silver dye-bleach. Color printing system that incorporates yellow, magenta, and cyan dyes into blue, green, and red emulsion layers during manufacture. During processing the unused dye areas are washed away. The best-known silver dye-bleach system is Cibachrome.

Silver halides. A general name for a group of light-sensitive chemicals used in photographic emulsions.

Solarization. The creation of a combination of a partially positive and negative image when a negative is greatly overexposed.

Spotting. Retouching of dust spots or scratch marks on paper or film.

Stock solution. Any processing solution that can be premixed in large batches and stored for later use in lesser amounts.

Stop bath. A chemical solution used to end the action of a developer.

Test strip. A series of different exposures on a single piece of paper or film, used to find the optimal exposure.

Thin negative. An underexposed or underdeveloped negative lacking density and details, especially in the shadow portion.

Tonal deletion. The elimination of shades of gray from a print, producing a high-contrast print using only black and white.

Tonal range. The gradations of gray between the darkest and lightest areas of a print or scene.

Tone separation. *See* Posterization.

Tungsten light. A lightbulb containing a tungsten filament and giving light with a color temperature of about 3200°K.

Tungsten film. *See* Indoor film.

Ultraviolet radiation. Invisible energy just below the short-wavelength end of the visible spectrum, and present in many light sources.

Underdevelopment. Too little development due to too short a period in the developer solution or too cold a developer, resulting in reduced contrast, density, and color saturation.

Universal developers. Developer solutions that may be used for both film and paper processing.

Voltage stabilizer. Essential in color printing, a voltage stabilizer is an electrical device that keeps the voltage flow to the enlarger constant, preventing current fluctuations from affecting exposure.

Wetting agent. A chemical added to the last processing wash to ensure even drying.

Working solution. Chemistry that has been diluted and is ready for use.

Yellow. One of the primary additive colors.

Index